The Great Zentangle® Book

Learn to Tangle with 101 Engaging Patterns

Beate Winkler (CZT)
and 47 CZTs & Zentangle friends
from all over the world

QUARRY

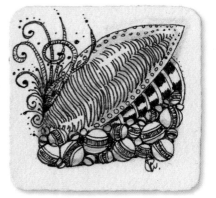

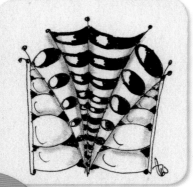

Welcome Bijou! For the first time presented in a book: the new small Bijou format 2" x 2" (5 x 5 cm)

Zentangle®

The Zentangle® Method is an easy-to-learn, relaxing, and fun way to create beautiful images by drawing structured patterns.

It was created by Rick Roberts and Maria Thomas.

"Zentangle" is a registered trademark of Zentangle®, Inc.

Learn more at www.zentangle.com

CZT15-Seminar, Providence, RI, USA

CZT get together with Rick and Maria in Amsterdam

Contents

Note: Country Codes

AUS = Australia
CAN = Canada
CH = Switzerland
CN = China
GER = Germany
NL = The Netherlands
UK = United Kingdom
US = United States (with state abbreviation)
ZAF = South Africa

Foreword

What a gift it is to stand knee deep in a pool of so many beautiful tangles (Zentangle patterns), and to know that artists from around the world sent in their 101 favorite patterns for this project. Masterful!

Zentangle is supposed to be relaxing—a way for you to come to rest and become focused—and we carefully structured this book with this principle in mind. *The Great Zentangle Book* includes 101 different tangles, depicted in two to six steps each. You'll find more than fifty variations and more than 200 possible combinations of patterns, all individually hand-drawn on almost 1,000 tiles.

More than fifty Certified Zentangle Teachers® (CZT) and Zentangle friends participated. They picked their favorite patterns and eagerly drew up step-by-step instructions and tangled them on tiles for you. They also wrote up personal contributions for the tangles.

In addition to so many sincere worldwide contacts, many beautiful tangle interpretations originated this way, which makes me very happy and deeply grateful for all the contributors. This book is a true treasure trove of inspiration.

And finally, after the German, Spanish, and Danish editions, you hold the English translation in your hands. Yeah! I'm so pleased about that, and so proud that all of these contributors trusted me with their work. Thanks, Mary Ann, for going on the ride which created this piece of art.

I wish you a lot of joy in the world of tangles and Zen.

How do you organize so many tiles?

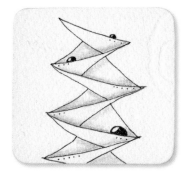

ING

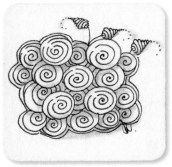

Printemps and Zinger

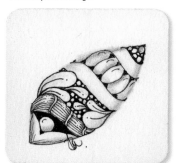

Purk, Fescu, and Zander

Tropicana and Printemps

Welcome!

Zentangle is a meditative drawing method.

Get inspired. Enjoy a small time-out and gift yourself something new, all of which will instantly make you feel good.

> Zentangle relaxes, calms, and is fun.
>
> Zentangle is easy-peasy for anyone who can hold a pen.
>
> Zentangle is possible always and anywhere: You only need a pen and paper.

Zentangle is equally suitable for children and adults.

With few materials, you can create beautiful patterns and small works of art immediately.

In all my classes, participants always start out cautious, sometimes hardly daring themselves to step up to the workshop table. But if you set aside just 15 minutes of your time, you'll have the opportunity to dive into the world of Zentangle.

Discover the phenomenon of simplicity, elegance, and beautiful results. From my experience, all people get up from the table and step into the world with a smile on their faces, distinctively more relaxed and as real fans of the artform.

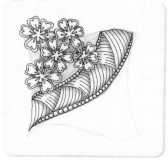

Shattuck and Herzlbee

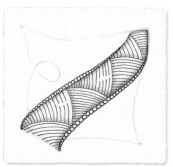

Shattuck

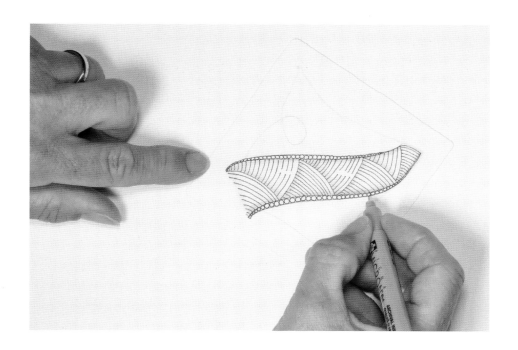

What is Zentangle?

Maria Thomas and Rick Roberts invented Zentangle. Maria is the creative (graphic design and calligraphy) half and Rick the meditative half (he spent seventeen years of his life as a Buddhist monk). In 2005, they developed Zentangle in the United States and have since spread the trend across the world.

To ensure the Zentangle philosophy and maintain quality, they now offer training for anyone interested in becoming a CZT®. Participants come from all around the world—just like me—and enthusiastically proclaim they are "Proud to be a CZT." You can find more details at www.zentangle.com.

Before we get started, there are some important concepts you should understand.

The core statement of Zentangle:

>> **Anything is possible, one stroke at a time.**® <<

Zentangle: What do I do?

The confusing thing about the word "tangle" is that it can be used as a verb as well as a noun. So, "I tangle" could mean: "I draw a pattern on a tile." However, you could also tell someone, "I tangle a tangle on a tile."

There are recognized Zentangle terms, and several are used throughout this book.
For instance:

- To tangle = to draw
- A tangle = pattern or tangle
- Tile = paper card on which to tangle

You'll find the definitions of all the technical terms on page 128.

Finally, to clear up one more term: "Zentangle" is not used as a verb; instead, it's the company name and the trademark.

So, instead of saying, "I zentangle," you would say, "I like Zentangle,"or "I do Zentangle art." But keep in mind that "I tangle" always works.

Different results, just like the signatures.

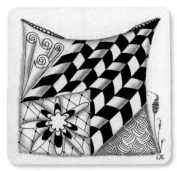

Catrin-Anja Eichinger, GER

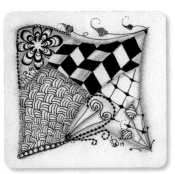

Combination of Keeko, Zenplosion Folds, Florz, and Zinger. Beate Winkler

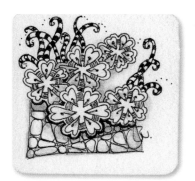

'Nzeppel and Herzlbee

Don't have time?

- Are you always rushing around? Are you impatient?
- Do you want to work off stress, escape the rush?
- Are you looking for some creative fun?

Then Zentangle is right for you!

What does "Zentangle" mean?

Zentangle comes from the word "Zen" meditation and "tangle" (entangled, interwoven) and combines creativity with meditation. Stroke by stroke, simple lines are repeated onto paper. Zentangle is an easy method to learn because it consists of structured patterns. With every line, you can dive further into the world of tangles. In a short time, tangles (also called "patterns") turn into amazing 3D, graphic, elaborate, beautiful tiles. They are unplanned, abstract, black and white. Before you begin, you don't know what the tile will look like. Every time something new emerges; it is your own, and it is always right.

Why is Zentangle such a big trend worldwide?

It calms, relaxes, and is fun. Anybody can learn it in a short period of time, and it requires only a few materials. Tangling is more about the doing. It is a way to enjoy the moment, tune out the daily routine (with all the thoughts and worries) and occupy the soul with the awareness of the meditative drawing—to emerge stronger and move on. Incidentally, a beautiful work of art emerges, and people who do it build self-confidence and pride in their work.

This experience is especially nice for those who insisted prior to starting that they can't draw.

> Every child is an artist.
> The problem is how to remain
> an artist once we grow up.
> —*Pablo Picasso*

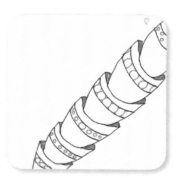

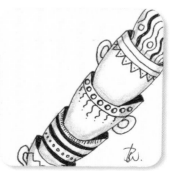

Potterbee

What Materials Do I Need?

Theoretically, you could get started anytime, anywhere, with any pen and scrap paper.

That works, but the result is more of a doodle. It happens accidentally, even unconsciously, like back when phones were connected to cords and every piece of paper nearby provided an opportunity to scribble.

Rick and Maria have tested many materials over the years and recommend the following equipment.

Pens

Zentangle Inc. recommends the high-quality Japanese fine-liner Sakura Pigma Micron Pen® 01 (0.25 mm) and 05 (0.5 mm), with good reason. They're deep black, pigmented, and permanent; they dry quickly and are light-resistant, and, honestly, not much more expensive than other good fine-liners. You can obtain them from CZTs and most art supply stores.

Pencils

Zentangle Inc. also launched pencils. Convenient, small, velvety soft, and a rich black in color. Usually one stroke is enough to show up well on paper. A regular pencil sharpener is also necessary.

Paper stump

A paper stump (also called a Tortillion) is helpful in case your fingers become too black from smudging pencil lines. Made of tightly wound paper, it is ideal for professional-looking shading. Erasers are frowned upon by both Zentangle inventors. However, I have to confess that if a border or dot bothers me in the composition, I will (guiltily) erase it.

Tiles

A tile is a card made of Italian paper called Tiepolo produced by Fabriano (100% cotton, handmade with rounded corners, with the Zentangle logo on the back). The size was chosen so a tangle can be drawn in a short period of time and is easy to take along anywhere; therefore, you can tangle at any opportunity. The size is usually given in inches ("). Multiple tiles could be arranged into a mosaic.

- 3½" (9 x 9 cm), classic tile
- 2" (5 x 5 cm), Bijou format, available since June 2014
- 4½" (11½ cm), Zendala format, round tile

For the collector: Bijou tiles come in a cute tin with a sweet explanation and three out of twenty-four collector tiles.

More materials are always possible, but at this point, Rick likes to remind people of "the elegance of reduction." The chapter Opportunities for Continuing Tanglers will detail the variety of materials for Zentangle (page 130).

The materials at a glance

The most beautiful thing about Zentangle is you'll only need a few materials! In the beginning, three things are enough:

- black fine-liner: the finer the better
- pencil: soft, at least 2B
- piece of paper: about 3½" x 3½" (9 x 9 cm)

For the impatient ones who want to get started right away: Grab a pen and tangle here—be happy.

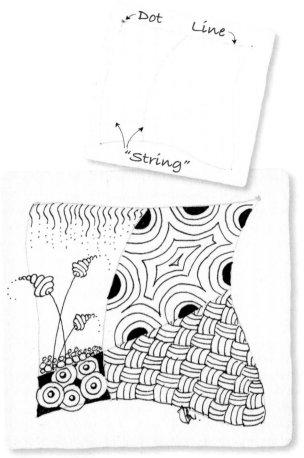

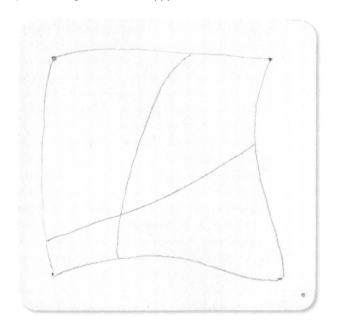

That's what my version looks like. And yours?
Combination of Keeko, Crescent Moon, Zinger, Msst, and Printemps.

If you enjoy tangling, you can order the original materials or even the Zentangle kit. In a nice box, you'll find all materials with comprehensive instructions, a DVD, and the famous Zentangle cube, which has twenty sides for random picking of tangles.

True greatness consists in being great in little things.
—Charles Simmons

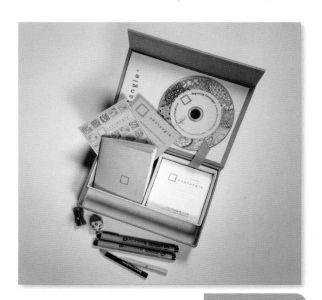

How Do I Start?

Zentangle is a very personal matter, and the design, like our handwriting, is very distinct. I would like to cordially invite you to our common journey into the world of Zentangle. Let's get going now.

1. Be conscious.

Congratulations, you're indulging in a time-out for a tangle. Maybe you even managed to make a little workspace for yourself so you'll have no distractions tempting you. Turn your phone off or put it on silent.

Take a deep breath and block out your environment. Give all your attention to the tile. Take it into your hands and feel the nice paper from which the tile is made.

2. Begin: Dot-dot

Make a small dot in every corner of the tile with your pencil. Already the tile is animated, and the fear of the white piece of paper has been reduced. (1)

3. Connect: Line-line

Make lines connecting the dots to form a border however you like—swooped or straight, with small loops or jagged. (2)

4. Divide: String

Draw a loose line or loop, i.e., a "Z" or a lowercase "l." This way we create sections for different tangles. The String is the magical part in which the creativity flows and can spread without being afraid to fail. (3a–c)

>> The time we take is time that gives us something back. <<
—*Ernst Ferstl*

1

2

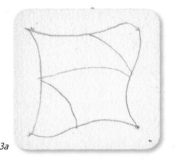

3a

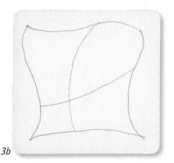

3b

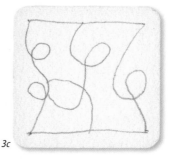

3c

5. Tangle

Now pick up the fine-liner. Which pattern do you like? Which section is going to work for it? Just start: Consciously and with concentration add one line after the other. (4) The elegance comes from the repetition. Enjoy the ease and calm that emerge. It is really simple, line by line, line by line. The calming effect brought about from tangling is that prior to starting you never know what the finished tile will look like.

4

Once the first section is filled, pick the next one, i.e., light next to dark, gridded next to free flowing, detailed next to widespread. (5) Feel free to leave a section blank or let it fall beyond the frame. That's exactly how the little artworks emerge. If you feel like, "Yes, that is appropriate for me," then that's how it shall be. (6) If you would like to shade your tangle, consider making a copy of your tile. If you don't feel right about your shading in the next step you can always return to your copy and start again.

5

6. Shade (In the beginning it works without shading, too.)

When you are just starting out, this is not necessary, but a pencil shadow adds an amazing 3D effect to your tangles. Simple passages will really jump out, while others move back into the depths. Use the following technique.

6

- Start by smudging the first pencil lines of the frame and the string with your finger or paper stump. You don't need to think about this one. (7)

- "What lies beneath something else?" That question is quickly answered. Shade the small places and transitions.

- "What is too flat, light, or empty?" If you find something along these lines, add light pencil marks at a pattern's edge and smudge them using small circular movements. (8)

7

- "Is there still something missing?" Then add some more shading to a spot or pattern. And if it still doesn't seem right, just erase what you've done or switch over to the copy you made earlier.

If all looks harmonious, then the tile is done. Congratulations!

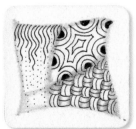

8

7. Completion: Sign. Appreciate. Be delighted.

Sign the tile with your initials, hold it at arm's length away from you, and value yourself for what emerged from within you and the time it took you to create it. (9)

How do you feel? Were you able to relax somewhat? Did you calm down? Then maybe you can go back to your everyday life a little stronger.

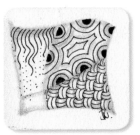

9

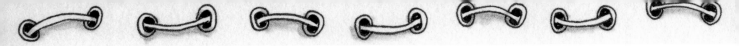

Curtains Up!

101 masterful tangles introduce themselves

Tangles are presented in three categories:

- Simple: Great tangles for getting started, every pattern pair makes a beautiful tile.
- Super: Tangles from A to Z to browse, marvel at, and have fun with.
- Brilliant: Tangles for the master class. You should try these tangles calmly and individually. They're very effective.

On each page you'll find one hand-drawn tangle along with its internationally recognized name and credit to the designer. You'll also find:

- Step-outs: Step-by-step instructions
- Final: Finished tangle with shading
- Variations: Tiles showing interesting interpretations, also known as Tangleation
- Combinations: Tiles with other patterns, usually named in the captions

For comparison's sake, you'll find some tangles in the last step shown purposefully without any shading.

The step-outs and combinations are enriched by variations. This creative stretching and testing was a lot of fun. Therefore, be brave and change up a pattern. Especially if you have a beautiful pattern you've been tangling for a while (I usually love it too, when I trace the pattern while free of thoughts), the excursion can be very rewarding.

Note: The tangle names you will see in parentheses do not appear as step-outs in this book.

The art of Zentangle is distinct, just like our handwriting, and it is nice to see that everybody comes up with something different. Some draw big, others small, some very busy, and others neat and clear. There is no wrong; everything is right as long as you like it. And if at one point you think, "Oh, I created the pattern completely wrong," then look again. It could be that a lovely variation has just emerged!

Are you looking for a particular tangle?

- Monotangles: Tripoli, Munchin, Winkbee, Goldilocks, Verdigogh

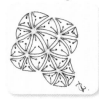

- Filler: Quipple, Onamato, Florz, Msst (top edge), Fescu (bottom edge)

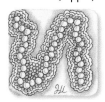 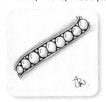

- All-over tangles: Keeko, Knightsbridge, 'Nzeppel, Cubine, Huggins-W2-Combination

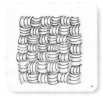 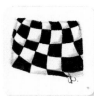 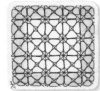 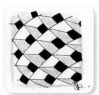 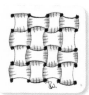

- A center piece (tangle first): Aquafleur, Tropicana, Quib

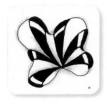 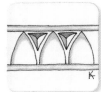

If you're not quite liking a tangled pattern because it is too loose or flighty, try using the tangle enhancer "Aura" by drawing a thin line around the pattern or the combination. It creates connectivity and anchors it, like it does with "Winkbee."

As with so many things, practice makes perfect. Even experienced CZTs devote themselves to one tangle once in a while. Take a look at Mooka (page 120). Dr. Lesley Roberts, CZT, depicts her struggles and journey into Mooka. She practiced the pattern over and over again for weeks, and the progress is easy to recognize.

Take your time and have the courage to experiment. If I'm starting a new pattern, I consciously allow myself to create a study first. If you like a pattern, you'll find your own way to tangle it.

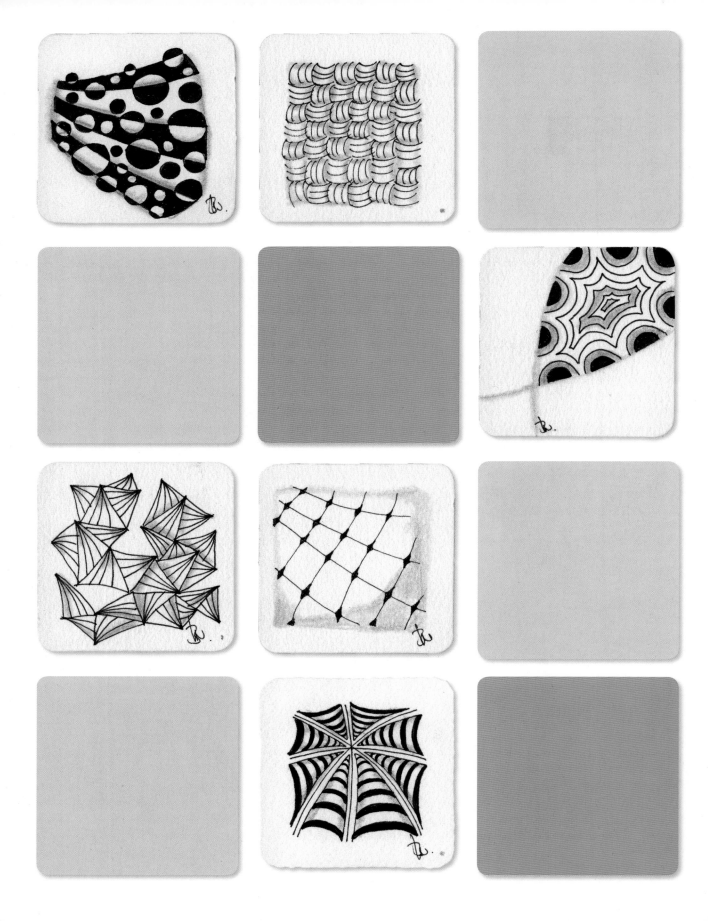

Great Tangles for Getting Started

Here you'll find easy-to-learn tangles divided into pattern pairs: The two patterns on each spread make a beautiful tile, which makes creating remarkable combinations easy!

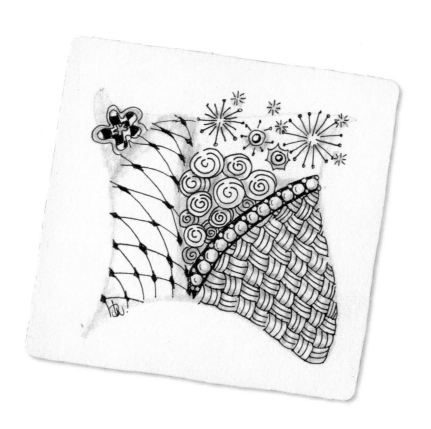

Zinger

Designer: Maria Thomas, Zentangle HQ, USA/MA

I really use Zinger always and everywhere. Even on my business cards or envelopes, I'll add a Zinger. I almost believe it is the fastest of all tangles and has a great effect. (Beate)

Variations: Zinger has many faces. The variations can look very diverse.

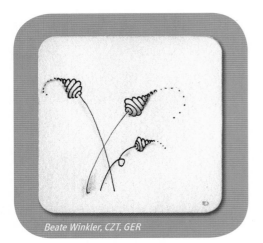

Beate Winkler, CZT, GER

Marty Vredenburg, CZT, USA/MI

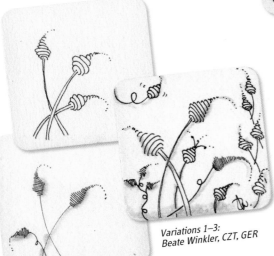

Variations 1–3:
Beate Winkler, CZT, GER

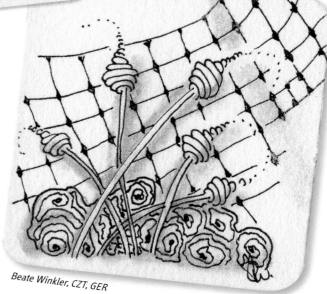

Beate Winkler, CZT, GER

Designer: Molly Hollibaugh, Zentangle HQ, USA/MA

Strircles
is simple and
quickly creates depth
through all the
black. (Beate)

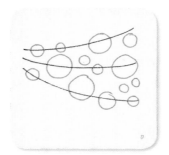

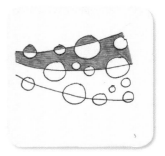

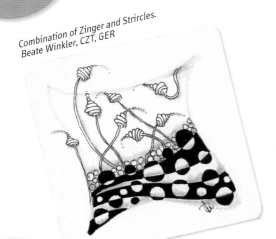

Combination of Zinger and Strircles.
Beate Winkler, CZT, GER

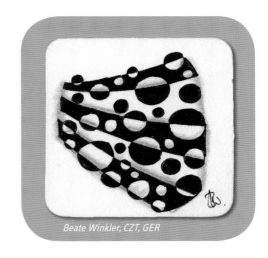

Beate Winkler, CZT, GER

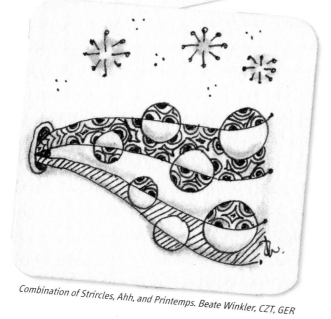

Combination of Strircles, Ahh, and Printemps. Beate Winkler, CZT, GER

Variation: Beate Winkler, CZT, GER

Ahh

Designer: Rick Roberts & Maria Thomas, Zentangle HQ, USA/MA

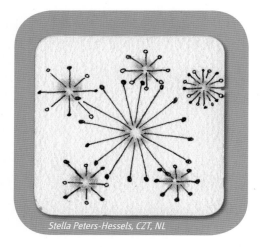

This tangle is my favorite pattern to draw because it is child's play—and the children love it, just like I do. (Stella)

Stella Peters-Hessels, CZT, NL

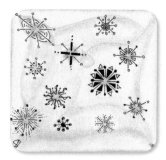

Variation:
Stella Peters-Hessels, CZT, NL

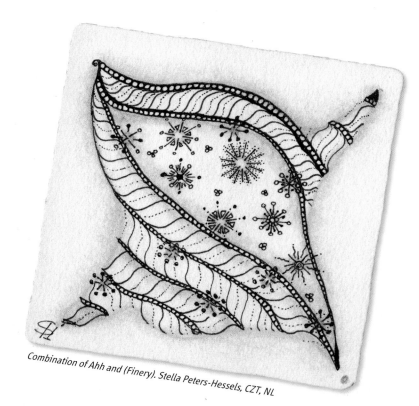

Combination of Ahh and (Finery). Stella Peters-Hessels, CZT, NL

Designer: Rick Roberts & Maria Thomas, Zentangle HQ, USA/MA

Keeko is marvelously simple and universally usable. It is one of the first patterns I learned and learned to love. (Beate)

Tip: Always turn the tile so that you can see it well and you can draw the lines comfortably.

Combination of Crescent Moon, Keeko, Zinger, (Kings Crown), Widgets, Onamato, and Cubine. Beate Winkler, CZT, GER

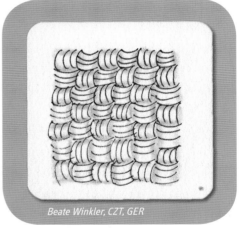

Beate Winkler, CZT, GER

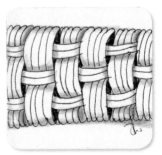

Variation: Beate Winkler, CZT, GER

Combination of Keeko, Onamato, and Crescent Moon.
Beate Winkler, CZT, GER

Crescent Moon

Designer: Maria Thomas, Zentangle HQ, USA/MA

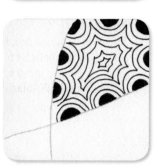

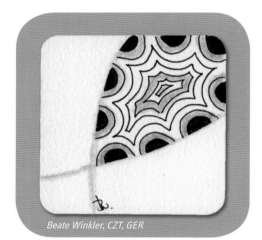

Beate Winkler, CZT, GER

I like Crescent Moon because it fits always and everywhere. It's interesting and easy to learn, and there are infinite variations. (Tina)

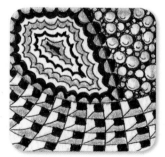

Combination of Crescent Moon, Cubine, and (Tipple). Beate Winkler, CZT, GER

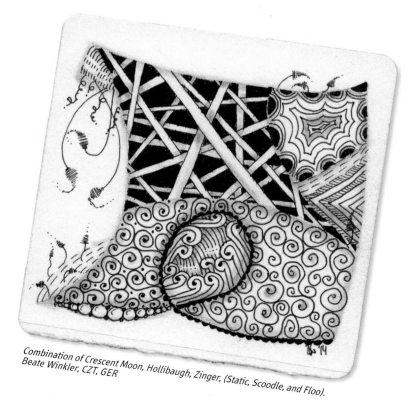

Combination of Crescent Moon, Hollibaugh, Zinger, (Static, Scoodle, and Floo). Beate Winkler, CZT, GER

Designer: Maria Thomas, Zentangle HQ, USA/MA

Oh, Onamato: My absolute favorite pattern! Balls over balls let the tile shine. Blissfully simple and in my variation with a little light reflections (black lines) you'll wonder whether they are rolling toward you. (Beate)

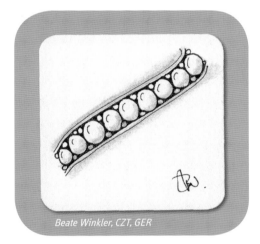

Beate Winkler, CZT, GER

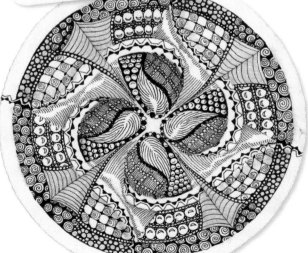

Combination of Onamato, Flux, Florz, Shattuck, Msst, and (Chartz). Beate Winkler, CZT, GER

Whether you are using it as a border or filler, Onamato always fits and looks impressive. (Beate)

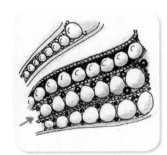

Variation: Beate Winkler, CZT, GER

The arrow points out the original tangle, Onamato. I like the top variation better, though, that's why I chose it for the step-out. (Beate)

Combination of Onamato, (Rain), Printemps, and (Pearl's). Stella Peters-Hessels, CZT, NL

7 Knightsbridge

Designer: Rick Roberts & Maria Thomas, Zentangle HQ, USA/MA

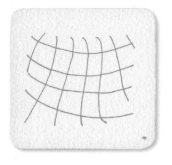 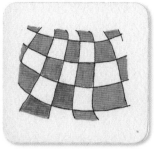

I like Knightsbridge because its name makes me curious. I could very well imagine the pattern on a victory flag during a medieval war or represented on the Formula 1 race flag. It is a basic pattern that has influenced many other tangles. (Stephen)

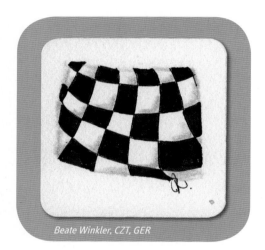

Beate Winkler, CZT, GER

Variation: Beate Winkler, CZT, GER

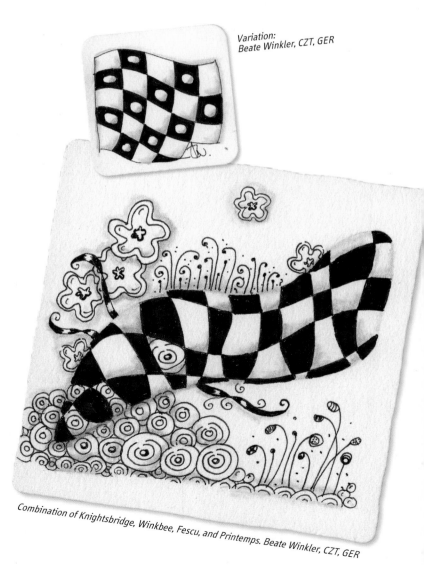

Variation:
Beate Winkler, CZT, GER

Combination of Knightsbridge, Winkbee, Fescu, and Printemps. Beate Winkler, CZT, GER

Designer: Beate Winkler, CZT, GER

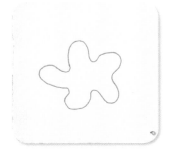

This pattern is so wonderfully simple. Five sweeps and it's done. It looks different each time—and always good. It quickly fills a space or a whole tile as monotangle. When you add the final touch, play around with the shading. (Beate)

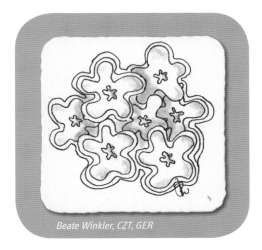

Beate Winkler, CZT, GER

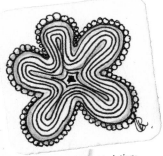

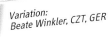

Variation:
Beate Winkler, CZT, GER

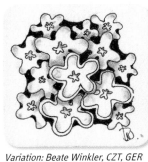

Variation: Beate Winkler, CZT, GER

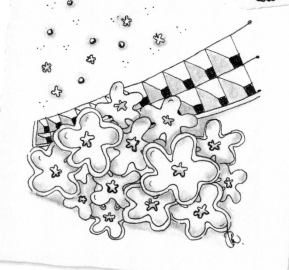

Combination of Winkbee and Cubine. Beate Winkler, CZT, GER

Winkbee likes Aura. Meaning, simply draw a line around the shape. Interrupt it too sometimes, that's called Sparkle. Aura also works when the line is drawn around the whole group. (Beate)

Luv-A

Designer: Sharon Caforio, CZT, USA/IL

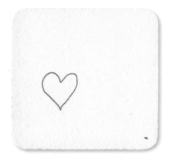 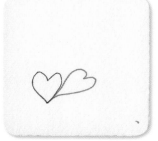 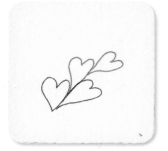 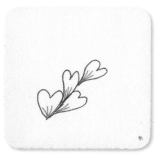

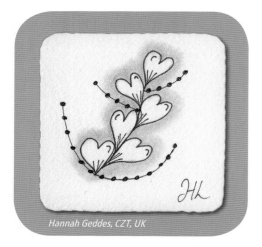

Hannah Geddes, CZT, UK

I love Luv-A because it has a beautiful, flowing heart shape. It can either be used as a large format in the center or as small shapes to embellish the tiles. (Hannah)

Combination of Luv-A, Zander, (Diva Dance, and Chainging). Hannah Geddes, CZT, UK

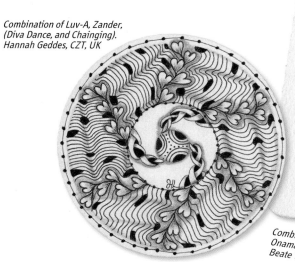

Combination of Luv-A, Aura-Leah, Potterbee, Bumbety Bump, Zander, Cubine, Onamato, Birds on a Wire, (Ribbon), Laced, and Henna Drum. Beate Winkler, CZT, GER

Designer: Maria Thomas, Zentangle HQ, USA/MA

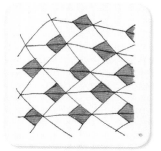

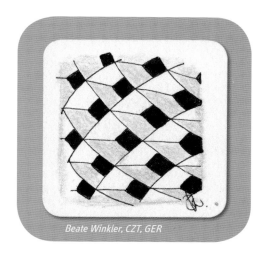

Beate Winkler, CZT, GER

Cubine was really the first pattern I tried. It's wonderfully simple (just the way I like it) and very effective. It works on a small surface and in a big space, quickly generating a fantastic depth. To this very day, I still like to use it, especially when I need a spot of black and a bold pattern fits well. (Beate)

Tip: Draw the horizontal lines (step 3) within the individual squares (from corner to corner) instead of in a long line across them all. Otherwise, it could go awry quickly. Align the inside boxes with their respective outer edge and center line.

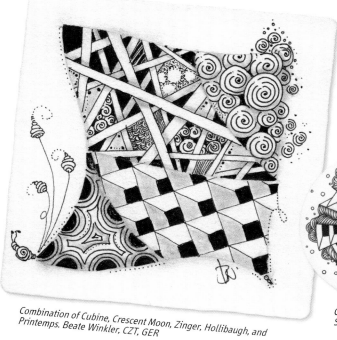

Combination of Cubine, Crescent Moon, Zinger, Hollibaugh, and Printemps. Beate Winkler, CZT, GER

Cubine and (Meer). Sandy Hunter, CZT, USA/TX

M'Spire

Designer: Katie Crommett, CZT, USA/MA

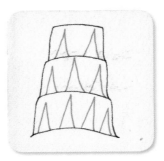
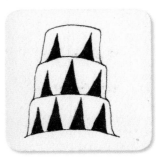

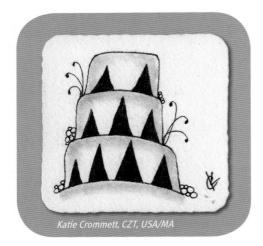

Katie Crommett, CZT, USA/MA

M'Spire is my first self-designed tangle. During a trip to New York City, I was inspired by the design of the Chrysler Building. I like how the pattern is simultaneously angular and soft. (Katie)

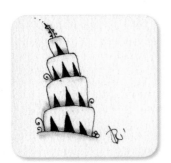

Variation: Beate Winkler, CZT, GER

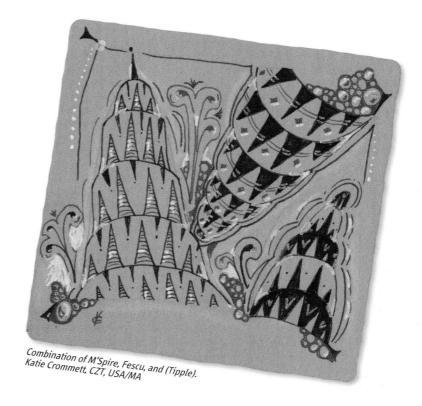

Combination of M'Spire, Fescu, and (Tipple).
Katie Crommett, CZT, USA/MA

Designer: Kate Ahrens, CZT, USA/MN

"Creativity is contagious. Pass it on." (Albert Einstein)

I like to use Widgets because it is a fun and simple pattern you can use to fill any kind of space. It also helps to add a little glitter to a piece of art. (Kate)

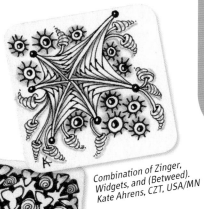

Combination of Zinger, Widgets, and (Betweed). Kate Ahrens, CZT, USA/MN

Kate Ahrens, CZT, USA/MN

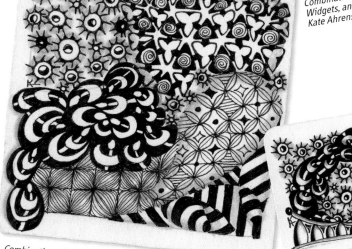

Combination of Widgets, Bunzo, (Striping), Tripoli, (Yincut, and Bales). Kate Ahrens, CZT, USA/MN

Combination of Widgets, Tropicana, and Bunzo. Kate Ahrens, CZT, USA/MN

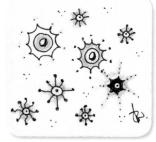

Variation: Beate Winkler, CZT, GER

13 Quipple

Designer: Rick Roberts & Maria Thomas, Zentangle HQ, USA/MA

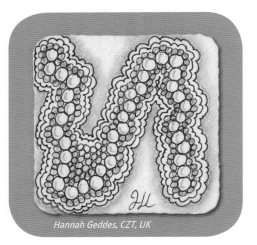

Hannah Geddes, CZT, UK

Quipple is so simple and effective. It can be drawn as a border around, angular, and sweeping. In any case, it brings the tile to life. (Hannah)

Quipple is a work of patience. I usually lack patience, so I admire the results even more! Thanks, Hannah and Tina.

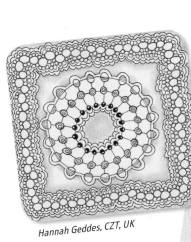

Hannah Geddes, CZT, UK

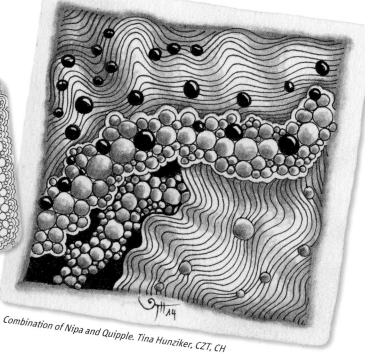

Combination of Nipa and Quipple. Tina Hunziker, CZT, CH

Designer: Molly Hollibaugh, Zentangle HQ, USA/MA

Tip: I use the pattern this way and that way. Either set the points before, like you see in the step-out. or maybe draw it without points—just attach it triangle to triangle.

With Munchin, you don't want to stop to add another triangle. Simple and beautiful, this relaxing pattern is especially good for creating a monotangle. (Beate)

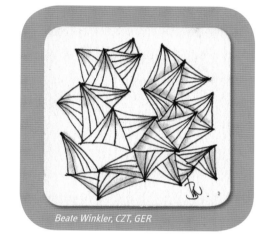

Beate Winkler, CZT, GER

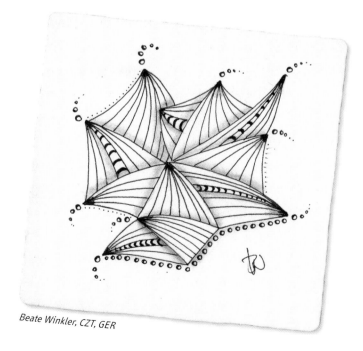

Beate Winkler, CZT, GER

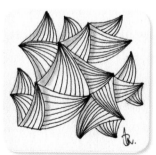

Variation: Beate Winkler, CZT, GER

Gryst

Designer: Frances Banks, CZT, USA/PA

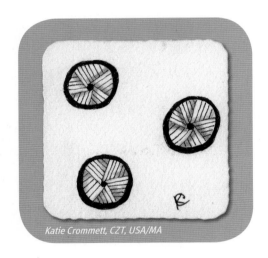

Katie Crommett, CZT, USA/MA

Gryst is adaptable. It can be used as filler or it can be filled with other patterns. I love this shape and its dimensions, which are called out through the shading. (Katie)

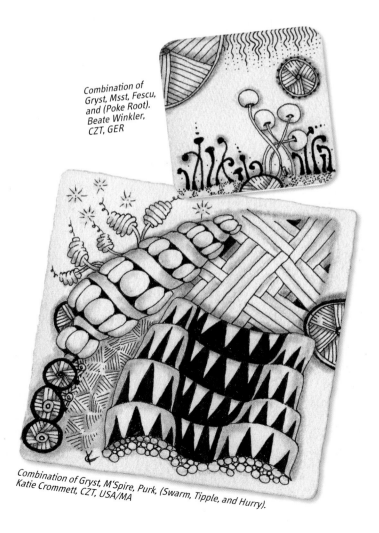

Combination of Gryst, Msst, Fescu, and (Poke Root). Beate Winkler, CZT, GER

Combination of Gryst, M'Spire, Purk, (Swarm, Tipple, and Hurry). Katie Crommett, CZT, USA/MA

Designer: Rick Roberts & Maria Thomas, Zentangle HQ, USA/MA

I like this pattern because it is easy to draw and provides many possibilities for fun. (Stella)

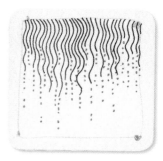

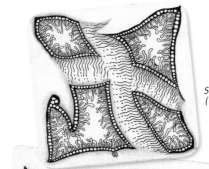

Stella Peters-Hessels, CZT, NL (With a very different string.)

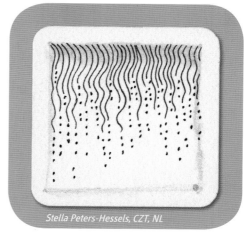

Stella Peters-Hessels, CZT, NL

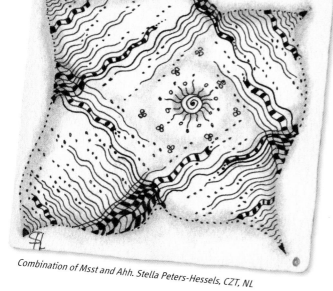

Combination of Msst and Ahh. Stella Peters-Hessels, CZT, NL

Variation: Msst is great for filling out the upper edge. It reminds me of Star Money, of *Grimm's Fairy Tales* fame. No sooner said than done: That's how my variation looks. (Beate)

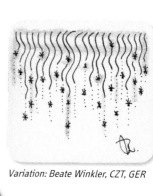

Variation: Beate Winkler, CZT, GER

17 Florz

Designer: Rick Roberts & Maria Thomas, Zentangle HQ, USA/MA

 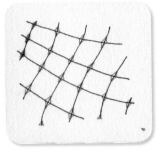 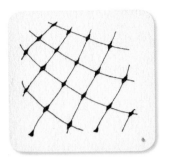

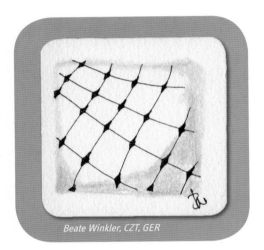

Beate Winkler, CZT, GER

I like Florz because it looks impressive. It can be used as a wonderful background and it covers big spaces well. (Deborah)

Variation:
Beate Winkler,
CZT, GER

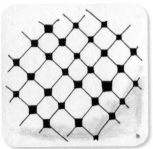

Variation:
Deborah Pacé, CZT, USA/CA

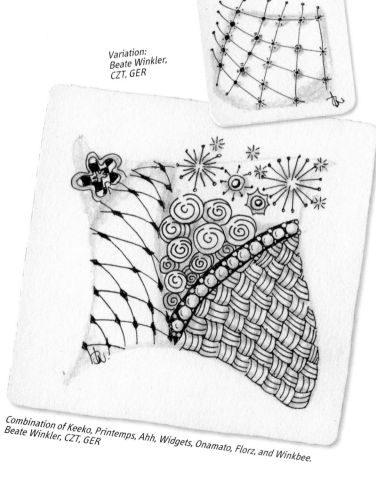

Combination of Keeko, Printemps, Ahh, Widgets, Onamato, Florz, and Winkbee.
Beate Winkler, CZT, GER

18 Aura-Leah

Designer: Carla Du Preez, ZAF/Pretoria

Aura-Leah is easy to draw, but it looks impressive and 3D. Good for use as an embellishment or as a centerpiece. (Beate)

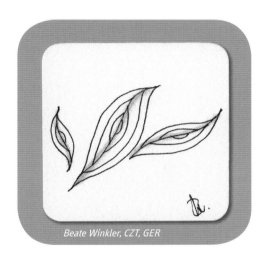

Beate Winkler, CZT, GER

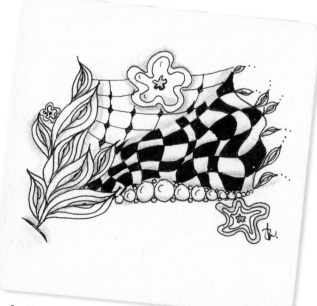

According to Rick Thomas, it has been proven that you listen better if you tangle. He encouraged us to do it during the seminar, which I found pleasant. (Beate)

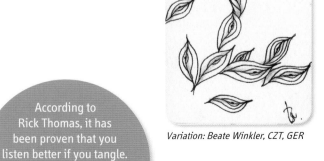

Variation: Beate Winkler, CZT, GER

Combination of Florz, Aura-Leah, Knightsbridge, Onamato, and Winkbee. Beate Winkler, CZT, GER

Fescu

Designer: Rick Roberts & Maria Thomas, Zentangle HQ, USA/MA

My tiles and pictures tend to be full and rich in detail. Fescu is an excellent option to use to loosen up the look of the tile. (Katie)

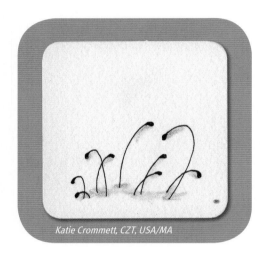

Katie Crommett, CZT, USA/MA

Combination of Fescu, Henna Drum, and Cruffle. Beate Winkler, CZT, GER

Variation:
Katie Crommett, CZT, USA/MA

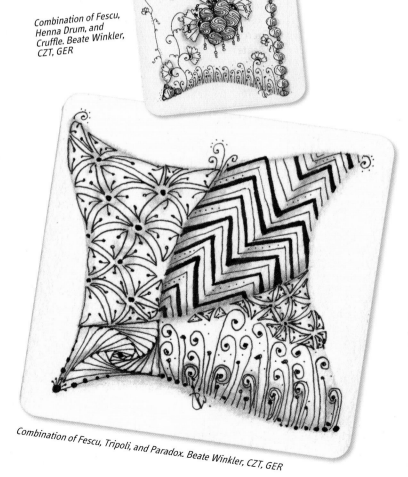

Combination of Fescu, Tripoli, and Paradox. Beate Winkler, CZT, GER

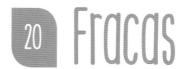

Designer: Rick Roberts & Maria Thomas, Zentangle HQ, USA/MA

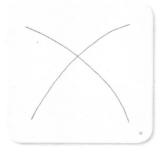 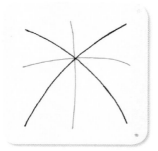 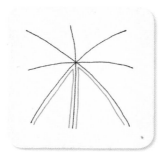

I love Fracas because it almost jumps out at you. It attracts attention on any tile; it looks very 3D and is just nice to tangle. Try to leave out the "V" and draw the curves in the other direction; you'll notice a spider web emerge. Even beginners really like this tangle. (Beate)

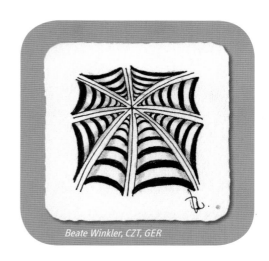

Beate Winkler, CZT, GER

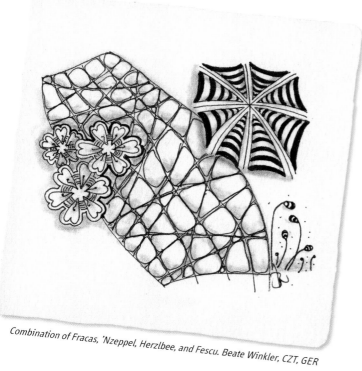

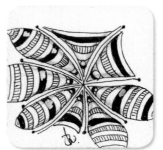

If you draw something "wrong," new variations develop. Beate Winkler, CZT, GER

Combination of Fracas, 'Nzeppel, Herzlbee, and Fescu. Beate Winkler, CZT, GER

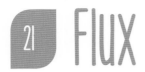

Flux

Designer: Rick Roberts & Maria Thomas, Zentangle HQ, USA/MA

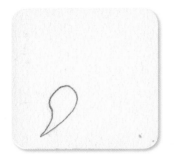 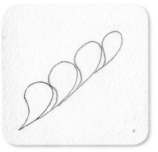 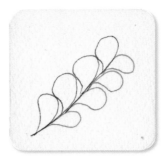 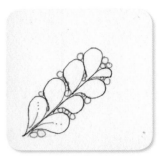

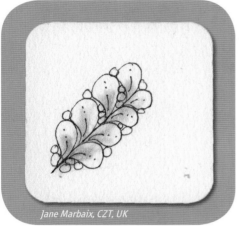

Jane Marbaix, CZT, UK

Flux, together with Cruffle,
always makes a beautiful
combination. (Jane)

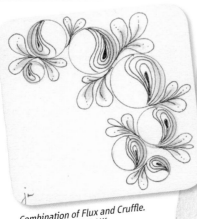

*Combination of Flux and Cruffle.
Jane Marbaix, CZT, UK*

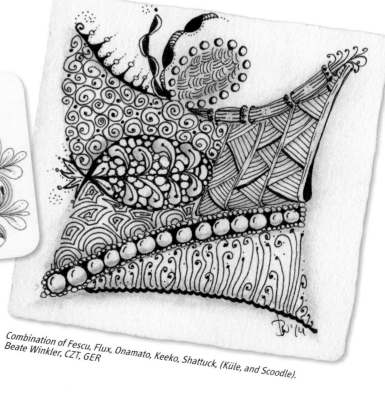

*Combination of Fescu, Flux, Onamato, Keeko, Shattuck, (Küle, and Scoodle).
Beate Winkler, CZT, GER*

Designer: Sandy Hunter, CZT, USA/TX

 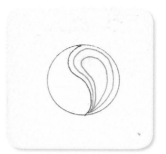 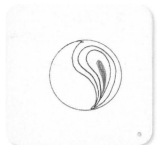

This pattern is fun to do and simple to draw. It can be used in various ways and still looks good even if it does not turn out perfectly round. (Sandy)

I like the pattern Cruffle because of its simplicity— it can be drawn freehand (or with a circle template), and if you add Flux to it, the result is beautiful. (Jane)

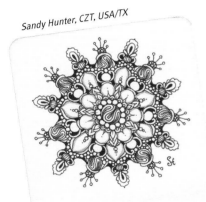

Sandy Hunter, CZT, USA/TX

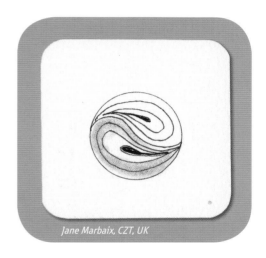

Jane Marbaix, CZT, UK

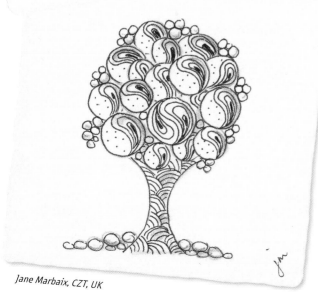

Jane Marbaix, CZT, UK

Variations:
Sandy Hunter, CZT, USA/TX

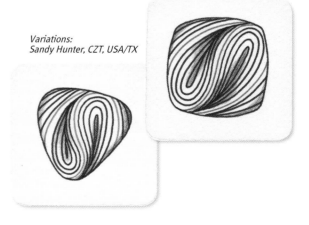

23 Printemps

Designer: Maria Thomas, Zentangle HQ, USA/MA

 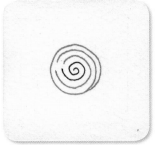 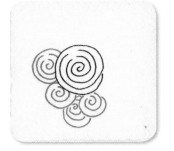 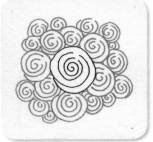

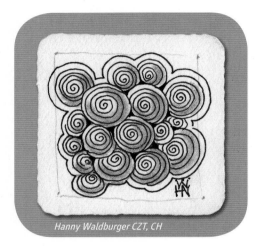

Hanny Waldburger CZT, CH

I love this pattern because I try to draw it as round as possible in every design. I try to draw it in different sizes and side by side. I can feel how my mind calms down when I draw this. Also, the pattern is interesting when it's shaded and takes on 3D shapes. (Stephen)

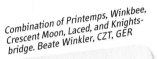

Combination of Printemps, Winkbee, Crescent Moon, Laced, and Knights- bridge. Beate Winkler, CZT, GER

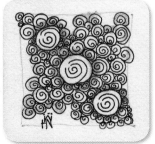

Variation: Hanny Waldburger CZT, CH

Printemps is one of my favorite tangles because it finds room anywhere; it adds light, movement, and dynamics; and because I feel at ease while drawing it. (Hanny)

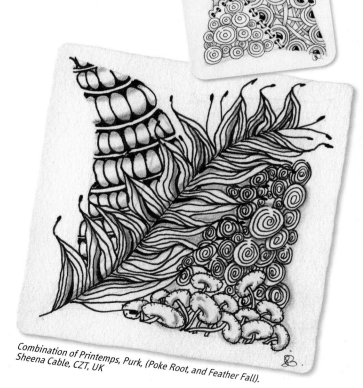

Combination of Printemps, Purk, (Poke Root, and Feather Fall). Sheena Cable, CZT, UK

Purrlyz
Printemps Variation

Designer: Hanny Waldburger, CZT, CH

Designer: Mary Elizabeth Martin, CZT, USA/CA

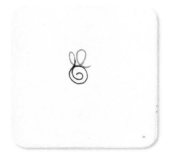

Laced is the favorite tangle of many CZTs. I like it a lot because of the 3D impression it gives, a little like MI2. It can be randomly decorated and it also works well as a border or transition between two patterns. (Hanny)

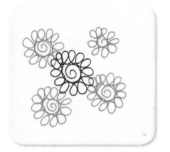

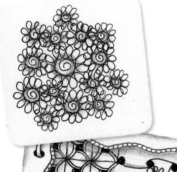

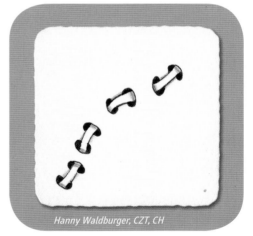

Hanny Waldburger, CZT, CH

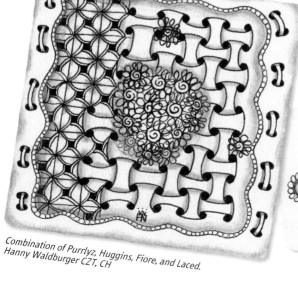

Combination of Purrlyz, Huggins, Fiore, and Laced.
Hanny Waldburger CZT, CH

Variation: Hanny Waldburger, CZT, CH

Variation: Hanny Waldburger, CZT, CH

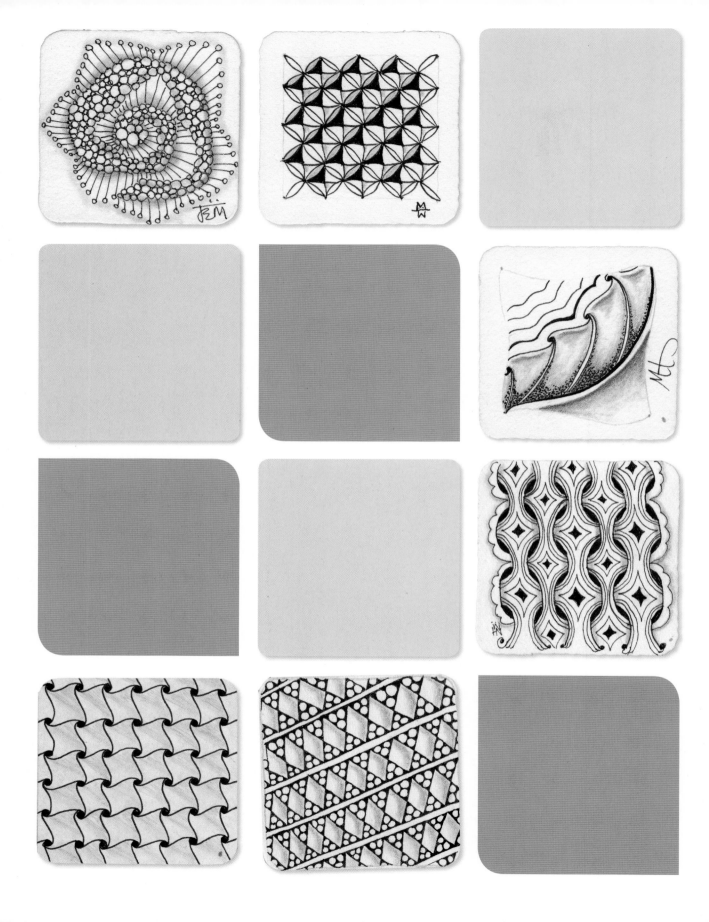

Exciting Tangles from A to Z

Has the Zentangle bug bitten you yet? In the following chapter, you'll find tangles that are a bit more complex. Therefore, they look fascinating and you can get lost in them and get into the flow.

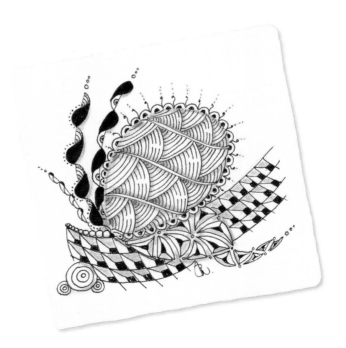

Angle Fish

Designer: Marizaan van Beek, CZT, ZAF/Pretoria

 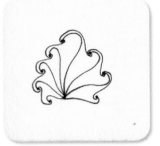

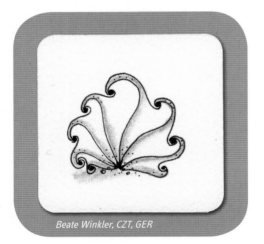

Beate Winkler, CZT, GER

I find Angle Fish funny. The name sounds nice and the tangle is simple and swooping. It makes me happy that we were able to add it to the book. (Beate)

Combination of Angle Fish and Cadent. Marizaan van Beek, CZT, ZAF/Pretoria

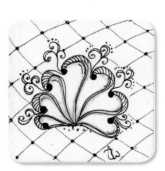

Variation: Beate Winkler, CZT, GER

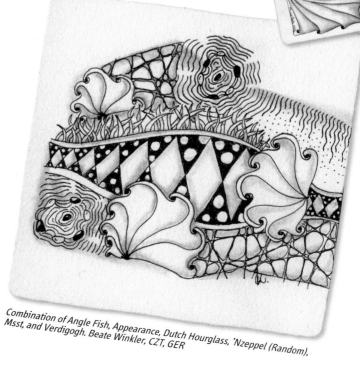

Combination of Angle Fish, Appearance, Dutch Hourglass, 'Nzeppel (Random), Msst, and Verdigogh. Beate Winkler, CZT, GER

Designer: Sandra Strait, USA/OR

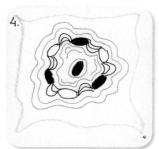

I like the pattern Appearance. It reminds me of a little stream I saw once—and I love the sound of running water. (Arja)

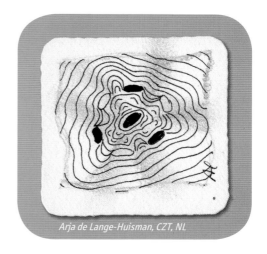

Arja de Lange-Huisman, CZT, NL

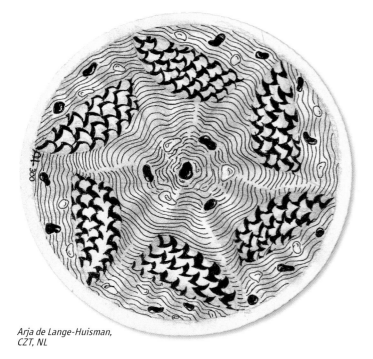

Arja de Lange-Huisman, CZT, NL

Variation Axlexa: Henrike Bratz, GER

Aquafleur

Designer: Maria Thomas, Zentangle HQ, USA/MA

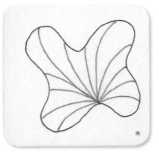
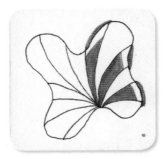

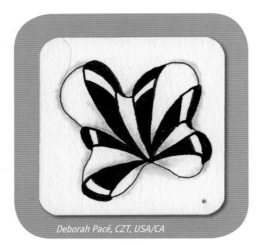

I like Aquafleur a lot because it looks like a flower to me. Once in a while, I like to draw it in color, because then it looks like a poppy flower. It is very versatile. (Deborah)

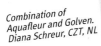
Deborah Pacé, CZT, USA/CA

Combination of Aquafleur and Golven. Diana Schreur, CZT, NL

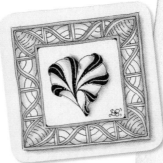

Combination of Aquafleur, Knightsbridge, and (Opus). Beate Winkler, CZT, GER

B-horn

Designer: Beate Winkler, CZT, GER

Trees fascinate me, therefore out of high regard, I have tangled a natural pattern. (Beate)

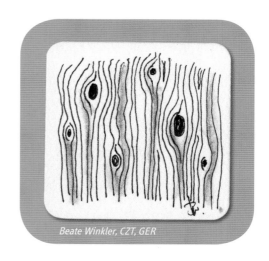

Beate Winkler, CZT, GER

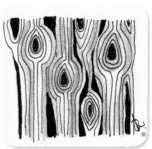

Variation: Beate Winkler, CZT, GER

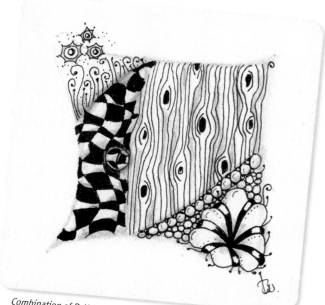

Combination of B-Horn, Knightsbridge, Aquafleur, Fescu, Widgets, and Onamato. Beate Winkler, CZT, GER

29 Birds on a Wire

Designer: Mary Kissel, CZT, USA/IL

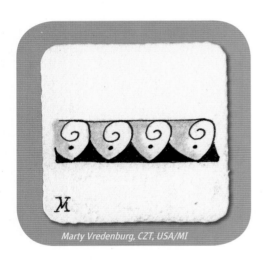

Marty Vredenburg, CZT, USA/MI

I like Birds on a Wire because it has hints of circles and triangles, and maybe because I have two pet birds! Here's something that makes me chuckle: I wanted to make the step-by-step instructions perfect for the book and used a couple dozen tiles until I thought to myself: "Phooey! I'll just do them the best I can and let that be good enough." That was hard for me—to just leave them be. (Marty)

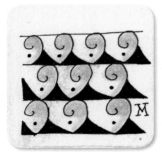

Variation: Marty Vredenburg, CZT, USA/MI

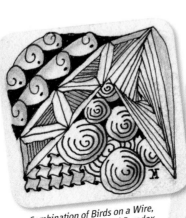

Combination of Birds on a Wire, Cadent, Printemps, and Paradox. Marty Vredenburg, CZT, USA/MI

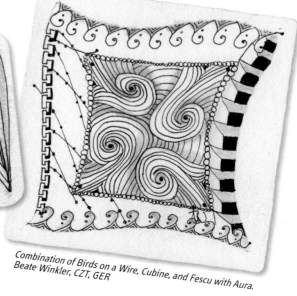

Combination of Birds on a Wire, Cubine, and Fescu with Aura. Beate Winkler, CZT, GER

30 Blooming Butter

Designer: Michele Beauchamp, CZT, AUS

In order to learn a pattern better, I like to create studies! For instance, with Blooming Butter, I first practiced the structure and then tried out various little circles for the center—finally adding varying shades. Can you see the little differences? (Beate)

Blooming Butter: Alone it looks harmless, but when you add more, it can start to go wild! (Michele)

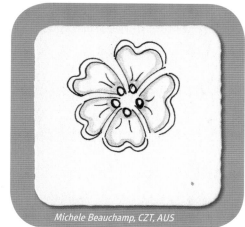

Michele Beauchamp, CZT, AUS

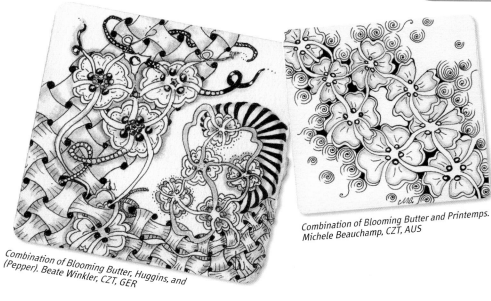

Combination of Blooming Butter, Huggins, and (Pepper). Beate Winkler, CZT, GER

Combination of Blooming Butter and Printemps.
Michele Beauchamp, CZT, AUS

31 Brayd

Designer: Michele Beauchamp, CZT, AUS

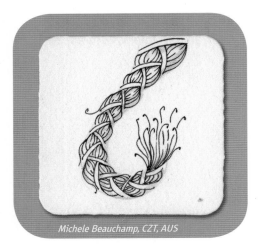

Michele Beauchamp, CZT, AUS

Brayd reminds me of a frayed braid. It can be clean and tidy, or it can be a bit scruffy with loose ends. (Michele)

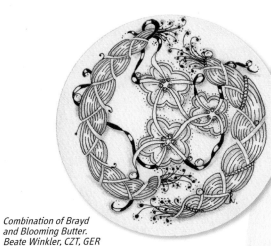

Combination of Brayd
and Blooming Butter.
Beate Winkler, CZT, GER

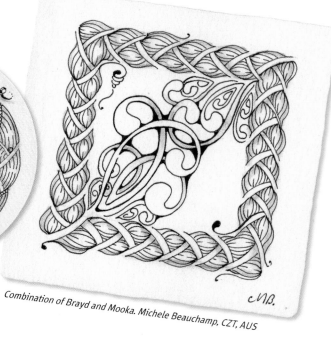

Combination of Brayd and Mooka. Michele Beauchamp, CZT, AUS

 # Bubble Bobble Bloop

Designer: Jane MacKugler, CZT, USA/VT

 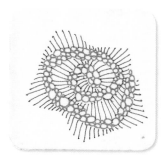 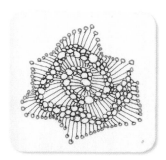

I like this pattern because my twenty-two-year-old son created it for my birthday. What a wonderful present! (Jane)

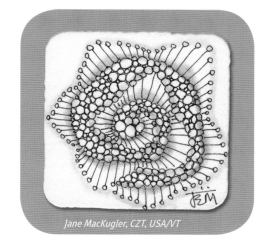

Jane MacKugler, CZT, USA/VT

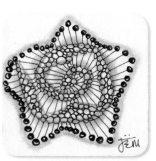

Variation:
Jane MacKugler, CZT, USA/VT

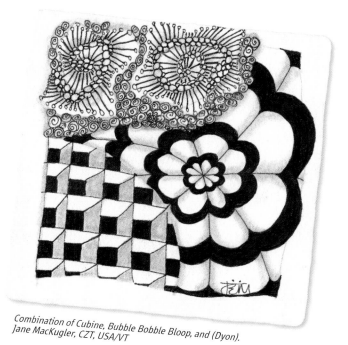

Combination of Cubine, Bubble Bobble Bloop, and (Dyon).
Jane MacKugler, CZT, USA/VT

Bumpety Bump

Designer: Judith R. Shamp, CZT, USA/TX

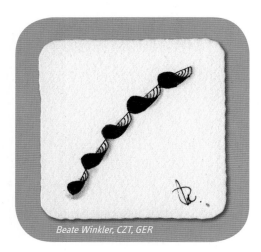

Bumpety Bump is a nice loosening up with a nice name, which you can use to break up a straight grid. And I like the 3D effect; it is simply lovely. (Beate)

Beate Winkler, CZT, GER

Variation: Beate Winkler, CZT, GER

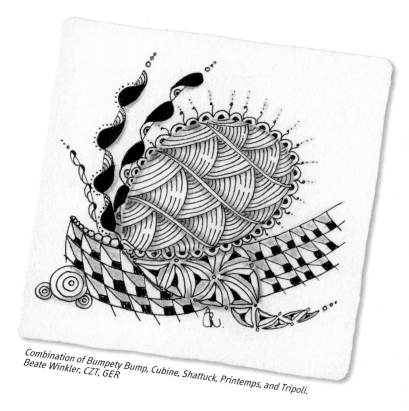

Combination of Bumpety Bump, Cubine, Shattuck, Printemps, and Tripoli.
Beate Winkler, CZT, GER

Designer: Beth Snoderly, USA/WV

 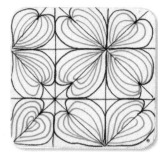

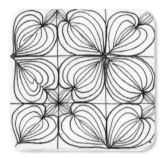

I like the symmetry of Bumpkenz. It looks beautiful not only as a monotangle, but also in combination with other tangles. Especially at the beginning, you have to concentrate, but once you get a hang of it, it is fascinating. (Hannah)

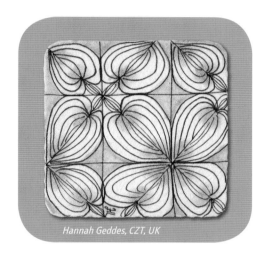

Hannah Geddes, CZT, UK

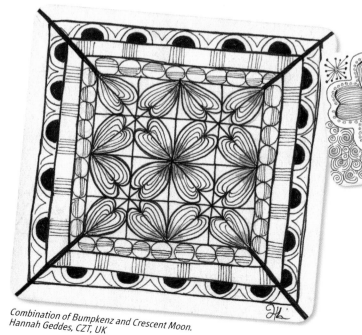

Combination of Bumpkenz, Keeko, Printemps, and Florz. Hannah Geddes, CZT, UK

Combination of Bumpkenz and Crescent Moon. Hannah Geddes, CZT, UK

Molly (seminar leader and daughter of Maria) used to say in a singsong way: "From point to line. And again from point to line. From point to line." This alone is calming.

Bunzo

Designer: Maria Thomas, Zentangle HQ, USA/MA

 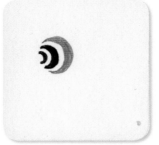 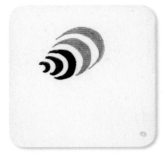 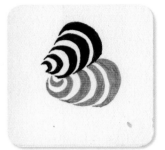

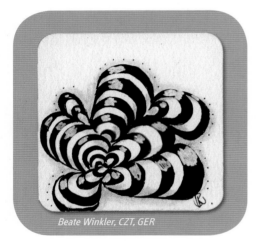

Beate Winkler, CZT, GER

Tip: Bunzo likes to sparkle! Either work it in right away or add the light spots afterward with a white Gelly Roll 08 from Sakura.

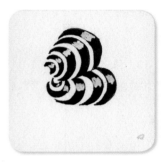

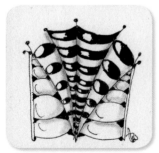

Variation: Beate Winkler, CZT, GER

Bunzo was more of a challenge for me—it usually looks more like a slug. The *aha*-reaction: Think about a mussel and smell the ocean. (Beate)

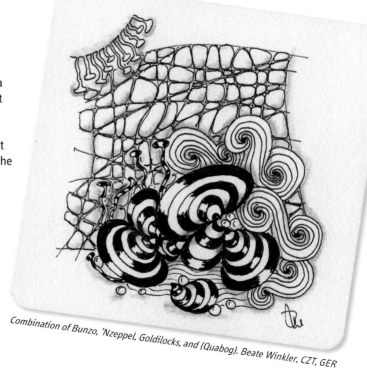

Combination of Bunzo, 'Nzeppel, Goldilocks, and (Quabog). Beate Winkler, CZT, GER

Designer: Maria Thomas, Zentangle HQ, USA/MA

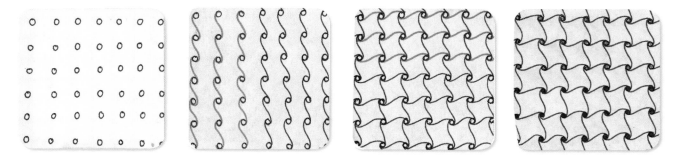

Rick has a tip for the soft S-curves: "Start above the circle and land nestled around the bottom circle. And start again and land."

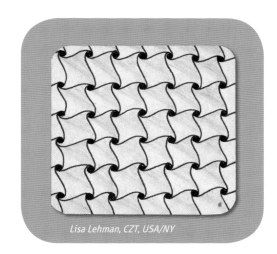

Lisa Lehman, CZT, USA/NY

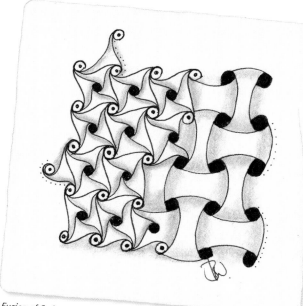

Fusion of Cadent and Huggins. Beate Winkler, CZT, GER

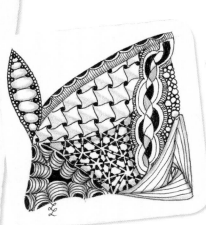

Combination of Cadent, Onamato, Crescent Moon, Tripoli, and Paradox. Lisa Lehman, CZT, USA/NY

Cat-Kin

Designer: Mimi Lempart, CZT, USA/MA

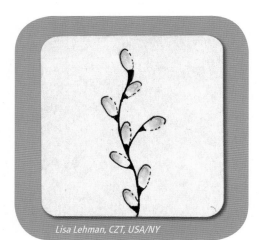

Lisa Lehman, CZT, USA/NY

Even if tangles are not supposed to be symbolic, this pattern, Cat-Kin, is still charming. This can be wonderful if drawn on tinted paper, and light reflections can be added to the "blossoms" with white pens. (Beate)

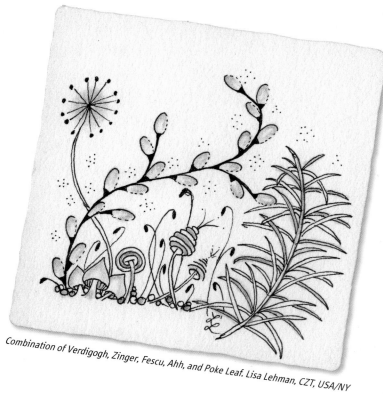

Combination of Verdigogh, Zinger, Fescu, Ahh, and Poke Leaf. Lisa Lehman, CZT, USA/NY

Designer: Sue Clark, CZT, USA/CO

 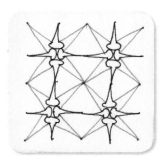

It starts out with a dotted grid, then add a simple C-shape, whereby you'll turn the tile a quarter turn until all Cs are touching. Draw the connection lines to the dots of the grid. In the last step, you can add a curve or a straight line or even both. As a variation, you can draw Ceebee without a grid. (Sue)

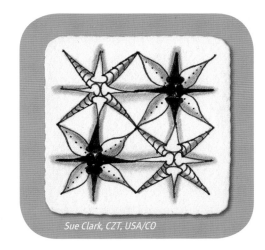

Sue Clark, CZT, USA/CO

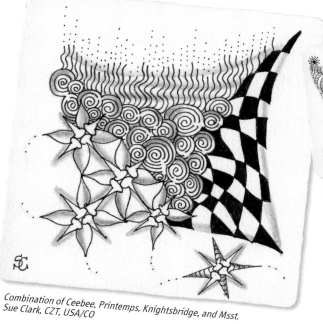

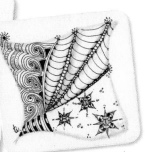

Combination of Ceebee, Birds on a Wire, and (Striping). Beate Winkler, CZT, GER

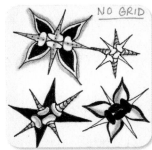

Variation: Sue Clark, CZT, USA/CO

Combination of Ceebee, Printemps, Knightsbridge, and Msst.
Sue Clark, CZT, USA/CO

Ceebee is a simple pattern that looks more complex than it is. (Sue)

39 Chainlea

Designer: Norma Burnell, CZT, USA/RI

 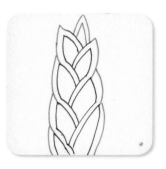

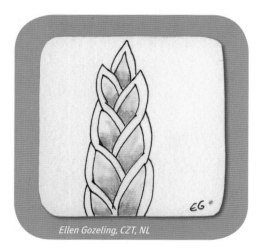

Ellen Gozeling, CZT, NL

I like Chainlea because it makes me focused, and it reminds me that nothing has to be perfect. (Ellen)

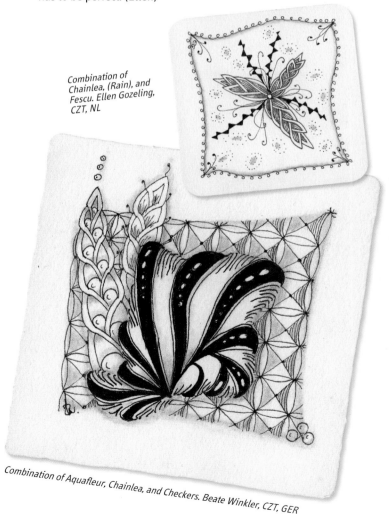

Combination of Chainlea, (Rain), and Fescu. Ellen Gozeling, CZT, NL

Variation: Ellen Gozeling, CZT, NL

Combination of Aquafleur, Chainlea, and Checkers. Beate Winkler, CZT, GER

Designer: Maiko Y. W. Wong, CZT, CN

 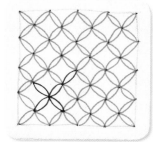

I like this pattern because it looks like the board game Nine Men's Morris. (Maiko)

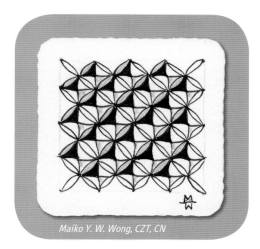

Maiko Y. W. Wong, CZT, CN

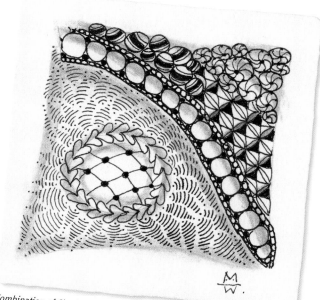

Combination of Checkers, Florz, Onamato, Qoo, (Jetties, Indy-Rella, and Festune). Maiko Y. W. Wong, CZT, CN

It is never about getting it finished. Instead, it is about the doing. All the more joy when something so beautiful is created. Through the monotony of the repetition everything becomes quiet within us. (Beate)

Chemystery

Designer: MaryAnn Scheblein-Dawson, CZT, USA/NY

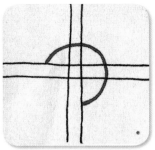
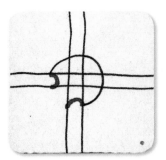
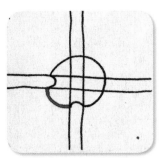

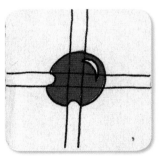
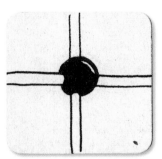

Step-out: MaryAnn Scheblein-Dawson, CZT, USA/NY

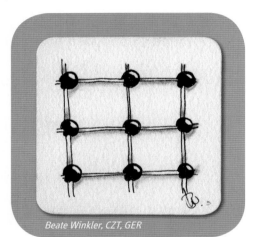

Beate Winkler, CZT, GER

I like Chemystery because you can obtain completely different results each time you illustrate it. (MaryAnn)

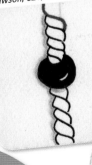

Variation: MaryAnn Scheblein-Dawson, CZT, USA/NY

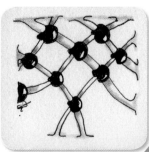

Variation: Beate Winkler, CZT, GER

If the simple S-curves are drawn with a fine-line pen and go diagonal across the straight lines (which I made with a pencil as guidelines) the hard, straight, geometric pattern transforms into a soft, lively version—like pearls on a strand. (MaryAnn)

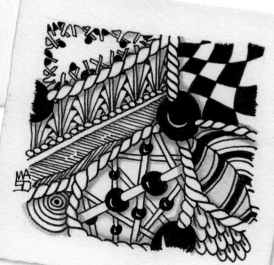

Combination of Chemystery, Knightsbridge, (Betweed, Bumper, Braze, Meer, and Tagh). MaryAnn Scheblein-Dawson, CZT, USA/NY

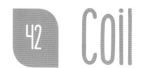

Designer: Sue Jacobs, CZT, USA/IL

 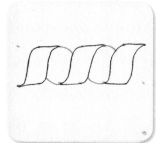 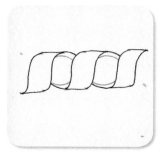

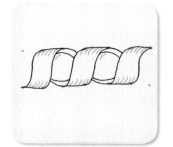

I find the tangle Coil simply impressive! It is lovely, 3D, and simple to tangle. It also has interesting variations. (Beate)

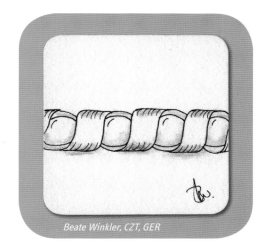

Beate Winkler, CZT, GER

Variation: Beate Winkler, CZT, GER

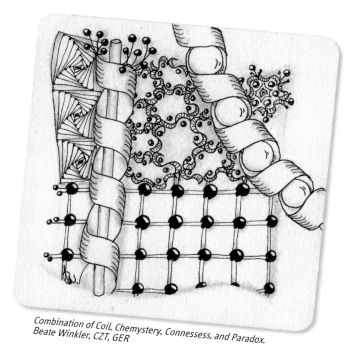

Combination of Coil, Chemystery, Connessess, and Paradox.
Beate Winkler, CZT, GER

Connessess

Designer: Diana Schreur, CZT, NL

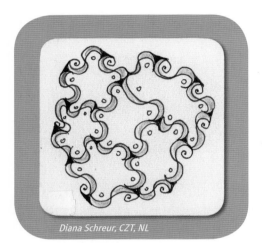

Diana Schreur, CZT, NL

I like the pattern Connessess a lot because it grows like a flower garden. (Diana)

Variation: Diana Schreur, CZT, NL

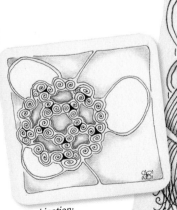

Combination: Diana Schreur, CZT, NL

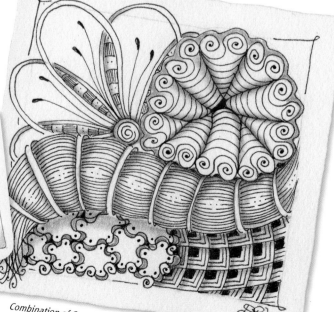

Combination of Connesses, Zander, and Flukes. Diana Schreur, CZT, NL

44 Cool 'Sista

Designer: Marizaan van Beek, CZT, ZAF/Pretoria

I love this tangle because it reminds me of a Koeksister, which is a twisted pastry dunked in cold ginger syrup.

Churches have been built with the money raised from selling these pastries, and there is even a monument dedicated to its humble origins. The pattern is flowing and when laid on top of one another it creates an impressive 3D effect. (Marizaan)

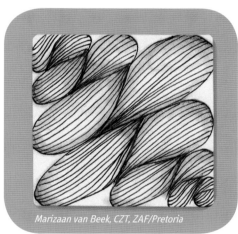

Marizaan van Beek, CZT, ZAF/Pretoria

Variation:
Marizaan van Beek, CZT, ZAF/Pretoria

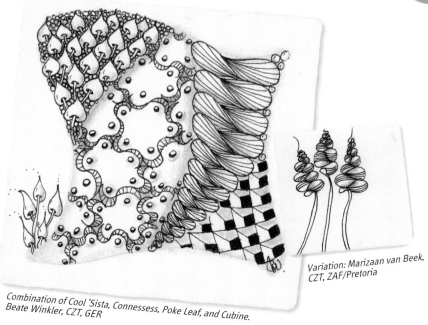

Variation: Marizaan van Beek, CZT, ZAF/Pretoria

Combination of Cool 'Sista, Connessess, Poke Leaf, and Cubine.
Beate Winkler, CZT, GER

45 Dessus-Dessous

Designer: Genevieve Crabe, CZT, CAN

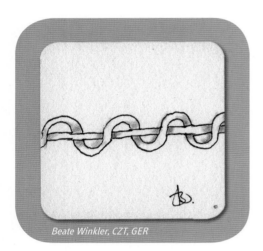

Beate Winkler, CZT, GER

Some patterns have a really nice 3D effect associated with them. This tangle obviously belongs in that category. The small subtlety in which the second end lines aren't drawn across but are instead added horizontally is important! (Beate)

Why does it look so different?

Take a closer look:

Already better!

Tip: Take a close look at this pattern. My version didn't look like the sample—until I noticed that I had drawn all the winding lines in front of the center bar. So if it doesn't happen to you, I've added the step-out to the left. (Beate)

Do you know how the String was drawn?

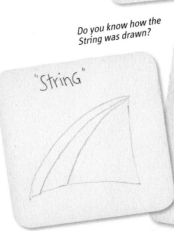

"String"

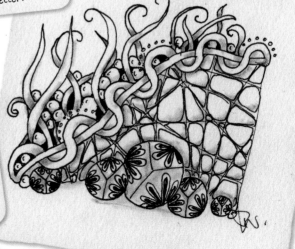

Combination of Dessus-Dessous, Kuke, and 'Nzeppel. Beate Winkler, CZT, GER

46 Ditto

Designer: Sue Jacobs, CZT, USA/IL

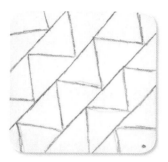 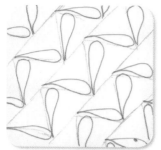 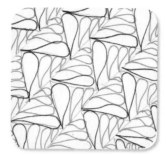

Tip: In the beginning, the lines and jags are drawn—as an exception—with a pencil. (Beate)

In the execution, Ditto is pretty in monotone. The distribution is determined after the first drop shape is added, and in the same motion, progressively smaller drops are tangled on bit by bit. (Ellen)

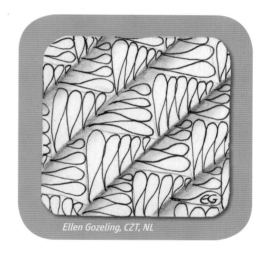

Ellen Gozeling, CZT, NL

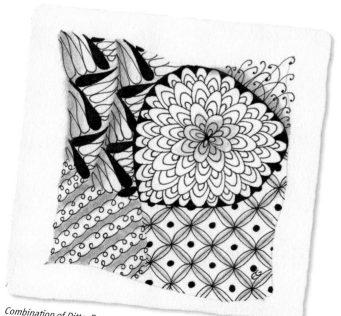

Combination of Ditto, Fescu, (Bales, Eke, and Arcflower). Ellen Gozeling, CZT, NL

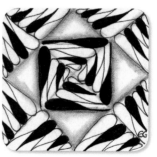

Variation: Ellen Gozeling, CZT, NL

Dragonair

Designer: Norma Burnell, CZT, USA/RI

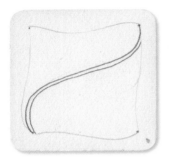 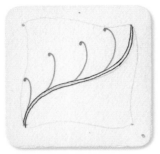 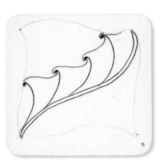 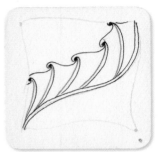

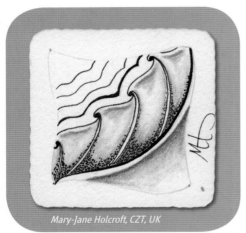

I like this pattern because, as the name already says, it reminds me of dragons, which are also my favorite creatures—even if they don't really exist. (Deborah)

Dragonair flows beautifully and brings movement to any tile. (Mary-Jane)

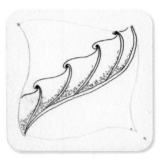

Mary-Jane Holcroft, CZT, UK

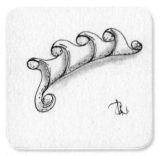

Variation: Beate Winkler, CZT, GER

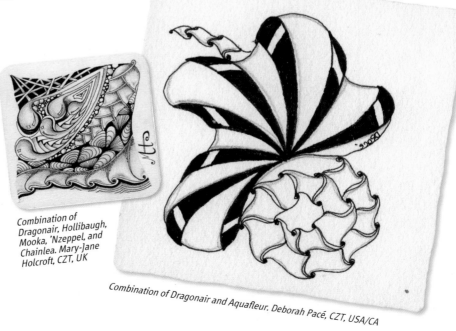

Combination of Dragonair, Hollibaugh, Mooka, 'Nzeppel, and Chainlea. Mary-Jane Holcroft, CZT, UK

Combination of Dragonair and Aquafleur. Deborah Pacé, CZT, USA/CA

48 Dutch Hourglass

Designer: Margaret Bremner, CZT, CAN

This pattern is my "godchild." The designer, Margaret Bremner, sat two rows behind me during the CZT seminar and was inspired by the pattern on my blouse. (Maria)

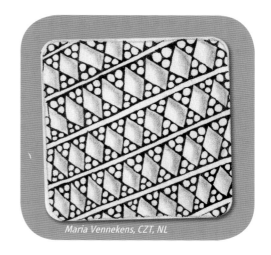

Maria Vennekens, CZT, NL

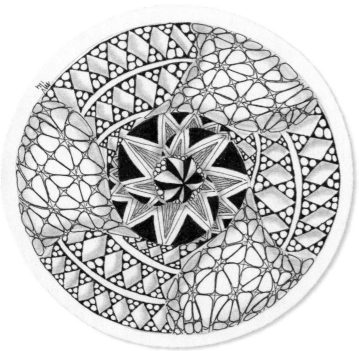

Variations: Maria Vennekens, CZT, NL

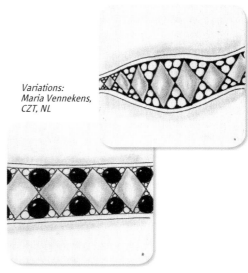

Combination of Dutch Hourglass, 'Nzeppel, (Gneiss, and Knase). Maria Vennekens, CZT, NL

Ennies

Designer: Maria Thomas, Zentangle HQ, USA/MA

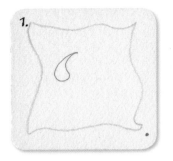
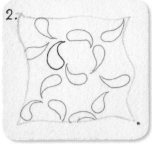
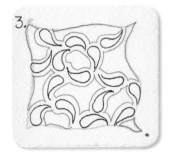
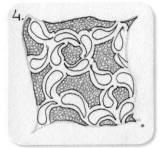

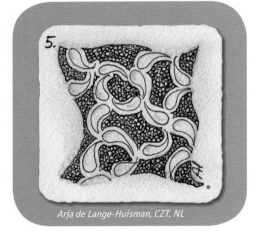

Arja de Lange-Huisman, CZT, NL

I like Ennies because it conveys a beautiful style. It flows like a small stream around the stones. (Arja)

Both examples are monotangles, which means that only this one pattern, Ennies, was used on the tile. I wouldn't have seen it right away! (Beate)

Monotangle:
Arja de Lange-Huisman, CZT, NL

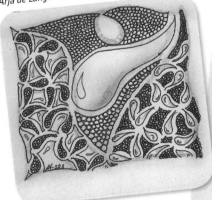

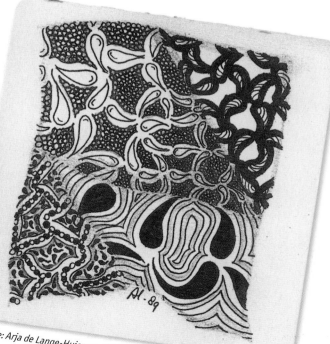

Monotangle: Arja de Lange-Huisman, CZT, NL

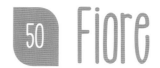
Designer: Jana Rogers, CZT, USA/ID

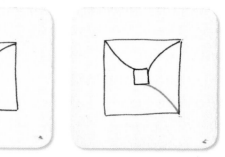

Hanny Waldburger, CZT, CH

Combination: Beate Winkler, CZT, GER

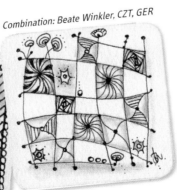

Variation: Beate Winkler, CZT, GER

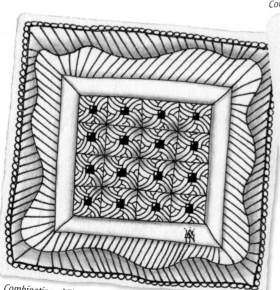

Combination of Fiore and (Meer). Hanny Waldburger, CZT, CH

Fiore is one of my favorite patterns, even though I'm usually not the grid-pattern type. But with Fiore, you can create great variations, which lets you forget that it is a grid pattern. It reminds me of Hawaiian lei flowers. (Hanny)

 Fjura

Designer: Hannah Geddes, CZT, UK

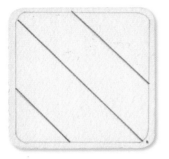 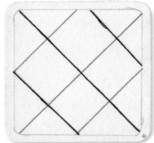 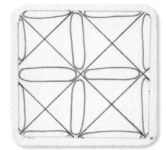 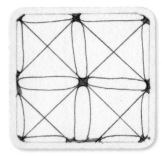

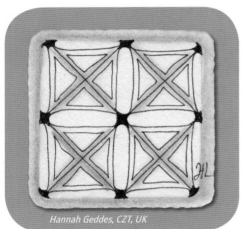

I love Fjura (Maltese for "flower") because it has a wonderful symmetry. (Hannah)

Hannah Geddes, CZT, UK

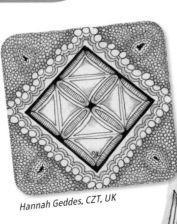

Hannah Geddes, CZT, UK

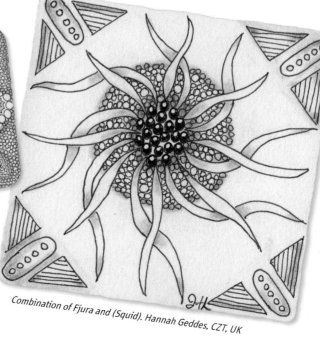

Combination of Fjura and (Squid). Hannah Geddes, CZT, UK

Designer: Beate Winkler, CZT, GER

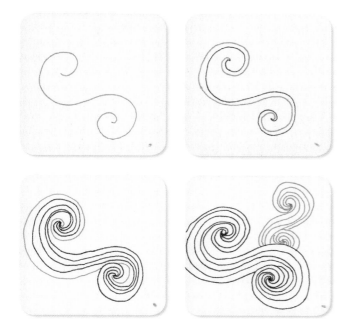

I love spirals. That's why some should absolutely be present in this book. So I just created Goldilocks, and I tinkered with it until it said "Good Day." I hope you like it just as much as I do. I love it especially after you shade the spiral centers and individual outside lines, which gives it a stronger 3D effect. It is a dynamic result, just like a roaring ocean. (Beate)

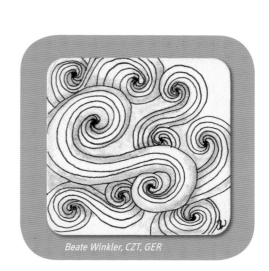

Beate Winkler, CZT, GER

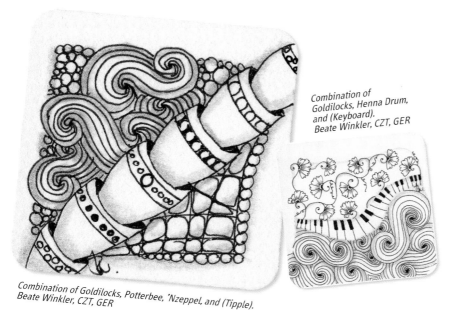

Combination of Goldilocks, Henna Drum, and (Keyboard). Beate Winkler, CZT, GER

Combination of Goldilocks, Potterbee, 'Nzeppel, and (Tipple). Beate Winkler, CZT, GER

I thought the keyboard was funny. I saw it somewhere on a tile and thought it would be easy to tangle. (Beate)

53 Golven

Designer: Mariët Lustenhouwer, NL

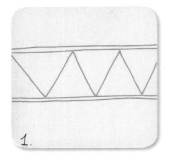

1. 2. 3. 4.

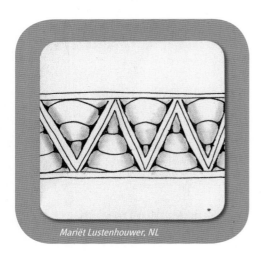

Mariët Lustenhouwer, NL

I like Golven a lot because it is usable as filler, a border, or even a string. (Diana)

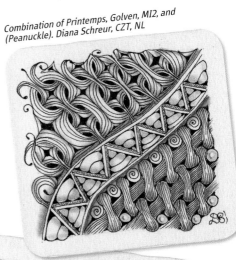

Combination of Printemps, Golven, MI2, and (Peanuckle). Diana Schreur, CZT, NL

VARIATION

Variation: Mariët Lustenhouwer, NL

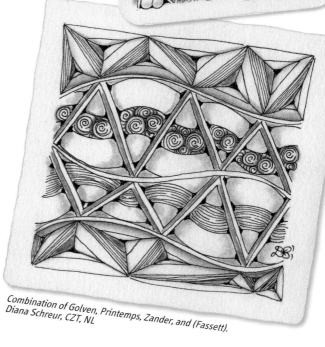

Combination of Golven, Printemps, Zander, and (Fassett). Diana Schreur, CZT, NL

54 Henna Drum

Designer: Jane MacKugler, CZT, USA/VT

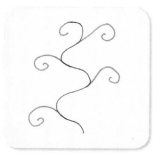
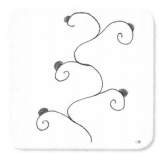
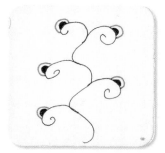

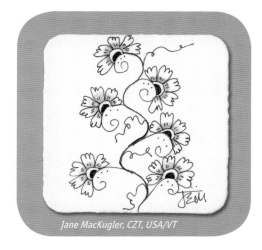

Jane MacKugler, CZT, USA/VT

I love this pattern because it is so perfect and dainty. I like floral designs, and thanks to Jane's instruction, Henna Drum is super-easy to tangle. (Beate)

The inspiration for this pattern came from a good friend who paints henna patterns on drums and people. I love the organic look of Henna Drum. (Jane)

I'm especially proud of this pattern because Jane was the first to agree to participate and give me approval right away to show this tangle in the book.

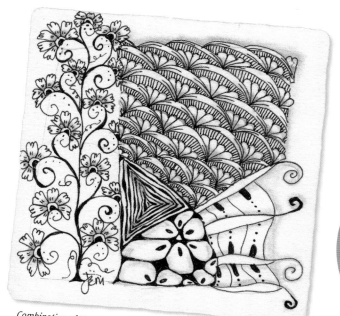

Combination of Henna Drum, (Diva Dance, Florez, Finery, and Cayke).
Jane MacKugler, CZT, USA/VT

Designer: Beate Winkler, CZT, GER

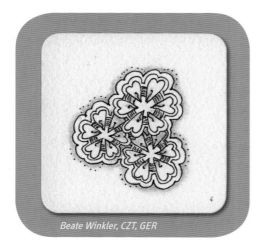

Beate Winkler, CZT, GER

The world needs more heart, so I created this tangle. I like flowers a lot, and strangely enough, the idea for this tangle was born when I saw a beautiful necklace on a woman riding the Zurich tram and spontaneously took a picture. (Beate)

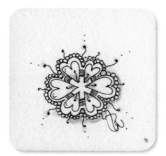

Variation: Beate Winkler, CZT, GER

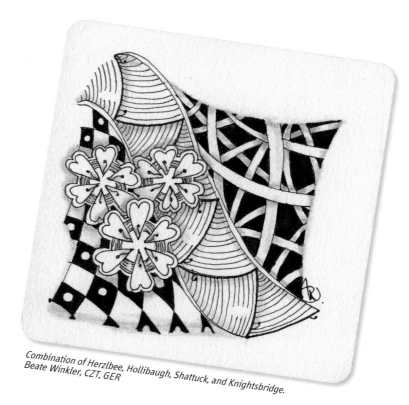

Combination of Herzlbee, Hollibaugh, Shattuck, and Knightsbridge. Beate Winkler, CZT, GER

Hollibaugh

Designer: Molly Hollibaugh, Zentangle HQ, USA/MA

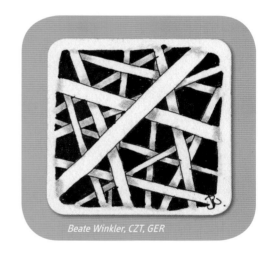

Beate Winkler, CZT, GER

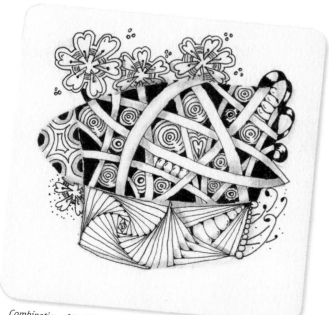

Combination of Hollibaugh, Paradox, Crescent Moon, Onamato, Fescu, and Herzlbee. Beate Winkler, CZT, GER

Variation Morse:
Margaret Bremner, CZT, AUS

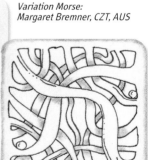

Variation: Beate Winkler, CZT, GER

Hollibaugh is a true classic, and is always willingly tangled. Maybe that is because it is amazingly easy to create impressive depths, and because it gives the tile a beautiful dark accent. (Beate)

57 Huggins-W2-Combination

Designer: Rick Roberts & Maria Thomas, Zentangle HQ, USA/MA

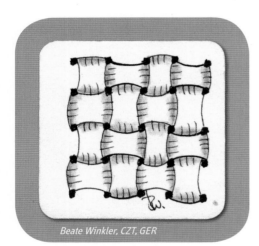

Beate Winkler, CZT, GER

This is the first pattern I taught myself. The first time I saw it, I was completely fascinated. I took it apart on my own and put it back together again and was later surprised to learn that it is actually a combination of Huggins and W2 with minor additions.

W2

Huggins

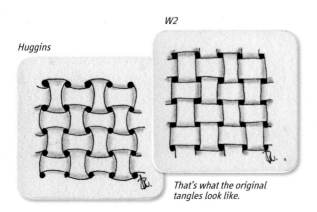

That's what the original tangles look like.

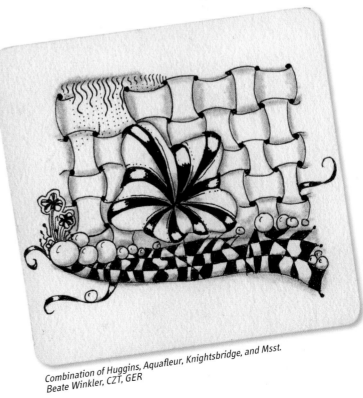

Combination of Huggins, Aquafleur, Knightsbridge, and Msst.
Beate Winkler, CZT, GER

Designer: Stephen Chan, CZT, CN

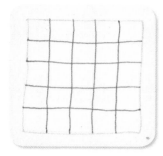 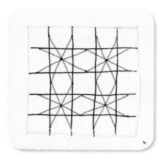 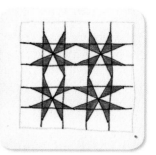

I like this pattern because it looks like the inside of a kaleidoscope. Sometimes you'll find an arrow, a pendant, or a diamond. It reminds me of my childhood. (Stephen)

String

Can you recognize the String?

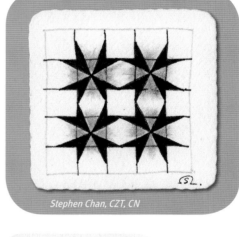

Stephen Chan, CZT, CN

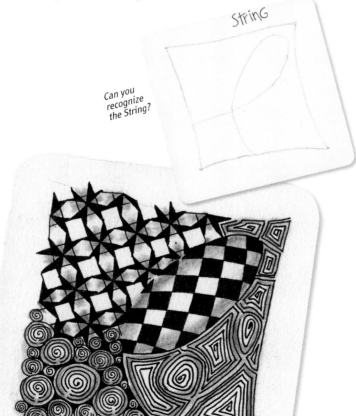

Combination of Kaleido, Printemps, Knightsbridge, and (Courant).
Stephen Chan, CZT, CN

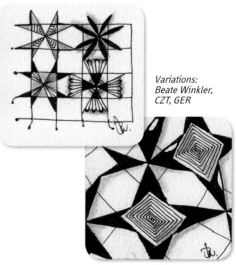

Variations:
Beate Winkler,
CZT, GER

Kettelbee

Designer: Beate Winkler, CZT, GER

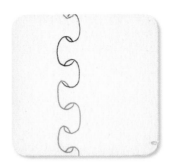
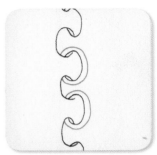

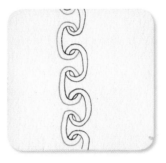

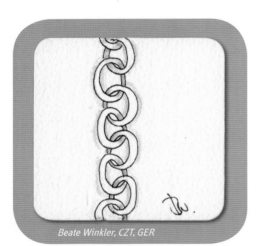

Beate Winkler, CZT, GER

Kettelbee interests me as a craftsperson. To tangle a chain straight from my mind has always been hard for me. That's why I deconstructed the chain until I simplified it down to the Cs. That way, I could finally—step by step—divide it into foreground and background until I was happy with the result.

There are many instructions for chains, but give Kettelbee a try. I hope it is as easy for you to tangle pretty variations as it is for me. (Beate)

Kettelbee is a beautiful example of how to take things from the environment, deconstruct them, and look for ways to reconstruct them step by step. Try until the end result is a happy one, and then build variations.

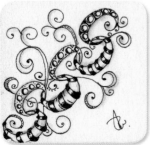

Variations: Beate Winkler, CZT, GER

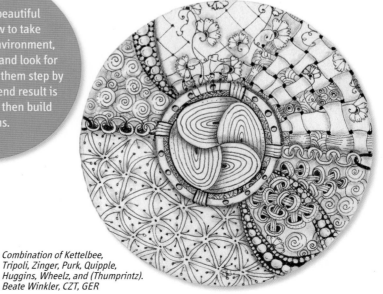

Combination of Kettelbee, Tripoli, Zinger, Purk, Quipple, Huggins, Wheelz, and (Thumprintz). Beate Winkler, CZT, GER

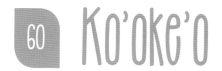

60 Ko'oke'o

Designer: Mary Kissel, CZT, USA/IL

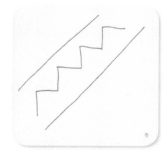 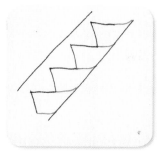 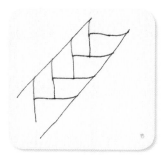 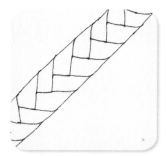

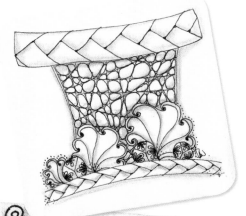

Combination of Ko'oke'o, Angle Fish, Kuke, and 'Nzeppel. Beate Winkler, CZT, GER

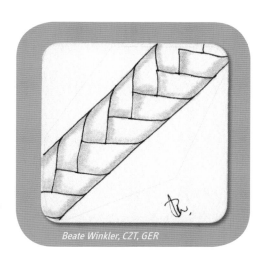

Beate Winkler, CZT, GER

Ko'oke'o is Hawaiian for "walking stick."

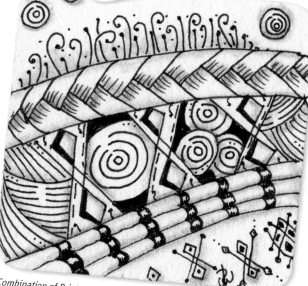

Combination of Printemps, Shattuck, Ko'oke'o, (X-Did), and Fescu. Beate Winkler, CZT, GER

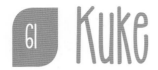

Designer: Katy Abbott, CZT, USA/OH

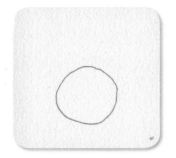 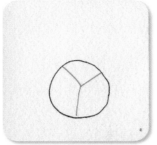 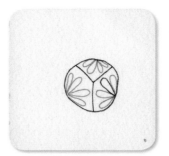

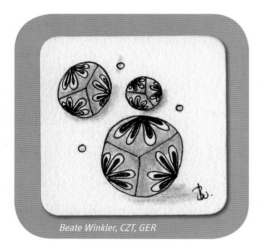

Beate Winkler, CZT, GER

Tip: In the original instructions, the "Y" is drawn first and then the circle. But because the circle often ended up not being very round, I tried it the other way around—and that worked great.

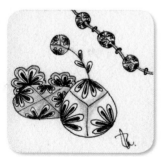

Variation: Beate Winkler, CZT, GER

I like these floral balls very much. They look like porcelain, so it seems Kuke could be tangled as a necklace. (Beate)

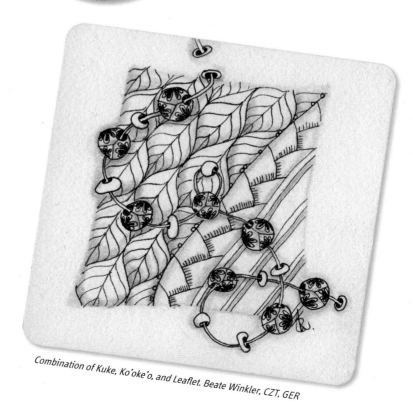

Combination of Kuke, Ko'oke'o, and Leaflet. Beate Winkler, CZT, GER

Designer: Helen Wiliams, AUS

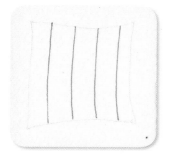 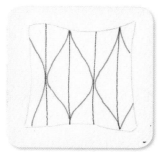 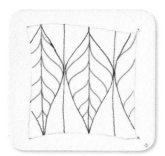 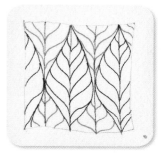

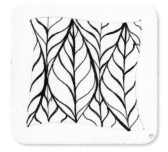

I admire Helen Wiliams's organic patterns. When the lines are drawn with a high contrast, it becomes even more vibrant. (Mary-Jane)

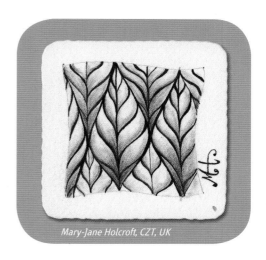

Mary-Jane Holcroft, CZT, UK

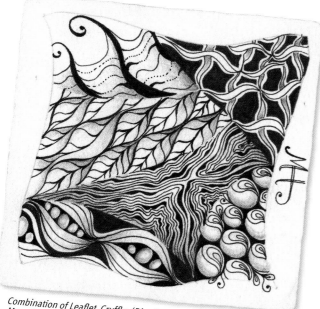

Combination of Leaflet, Cruffle, (Diva Dance, and Inapod). Mary-Jane Holcroft, CZT, UK

I like the fact that in this combination, everything flows and harmoniously belongs together, and it is distinctly blacker than my tiles. Thanks, Mary-Jane, for your artistic contribution.

63 Logjam

Designer: Wayne Harlow, CZT, USA/CA

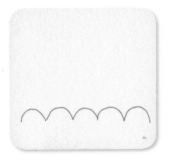
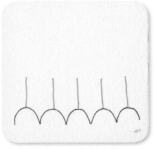
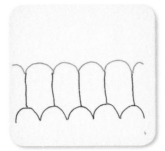

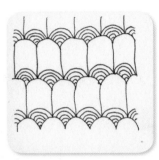

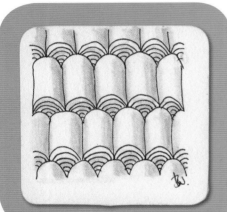

Beate Winkler, CZT, GER

Logjam reminds me of black licorice wheels. And the variation of Logjam reminds me of pretty, lined-up cut tree slices. Tidy and filling.

Variation: Beate Winkler, CZT, GER

When I asked Wayne for permission to use his tangle in this book, he wrote: "You're more than welcome to use the pattern as you see fit. I believe patterns are everywhere, and the only thing I did was deconstruct it, create a step-by-step instruction for drawing it, and give it a name. Therefore, I don't believe I 'own' the pattern, but thank you for asking." (Beate)

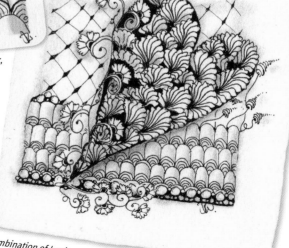

Combination of Logjam, Sanibelle, Henna Drum, Zinger, Florz, and Onamato. Beate Winkler, CZT, GER

Designer: Michele Beauchamp, CZT, AUS

 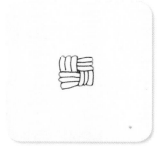 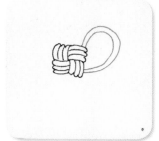 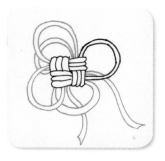

Mak-rah-mee is a very convenient tangle that can be used as a transition or connection pattern. The strings can be long, short, straight, or curved; they can curl or hang down. (Michele)

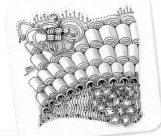

Combination of Mak-rah-mee, Logjam, Herzlbee, Nipa, and Kettelbee. Beate Winkler, CZT, GER

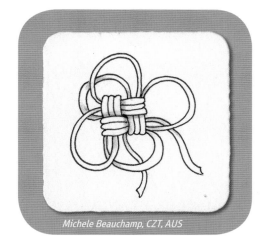

Michele Beauchamp, CZT, AUS

Variation: Beate Winkler, CZT, GER

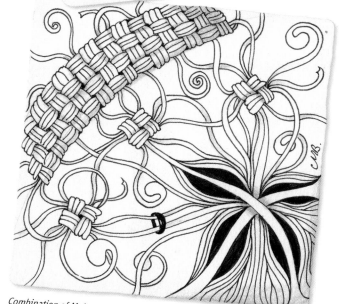

Combination of Mak-rah-mee, (Squill), and Keeko. Michele Beauchamp, CZT, AUS

MI2 (me too)

Designer: Mimi Lempart, CZT, USA/MA

 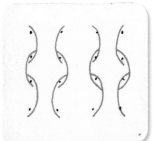 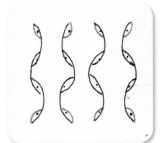 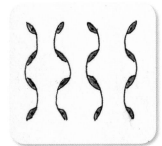

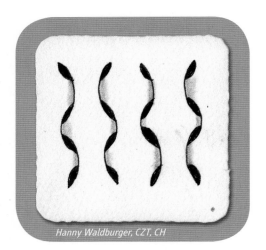

Hanny Waldburger, CZT, CH

MI2 is one of my absolute favorite tangles because I like everything woven, even though drawing it always challenges me. It is one of those patterns that takes a lot of concentration but can conjure great effects for a tile. (Hanny)

Maria Thomas modified this version of the step-out.

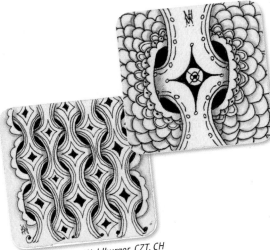

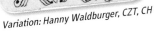

Variation: Hanny Waldburger, CZT, CH

Combination of MI2, Nipa, Poke Leaf, and Herzlbee. Beate Winkler, CZT, GER

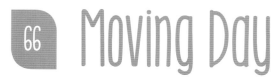

66 Moving Day

Designer: Margaret Bremner, CZT, CAN

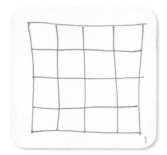
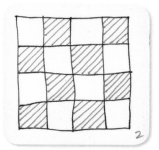
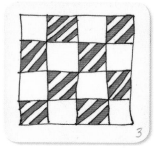
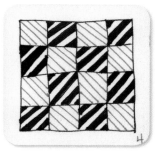

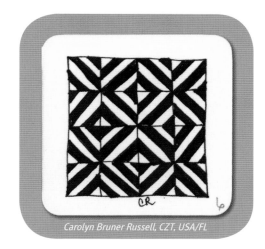

Carolyn Bruner Russell, CZT, USA/FL

I like Moving Day because it adds weight to any piece of art. It seems dramatic and is also usable as a border. I always come back to this interesting tangle. It has become one of my favorite patterns. (Carolyn)

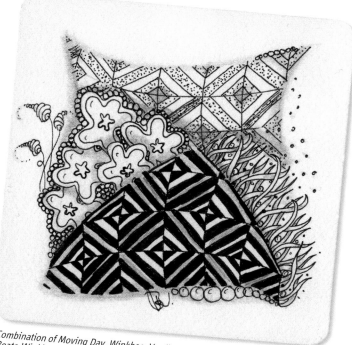

Combination of Moving Day, Winkbee, Verdigogh, and Zinger.
Beate Winkler, CZT, GER

Nipa

Designer: Rick Roberts & Maria Thomas, Zentangle HQ, USA/MA

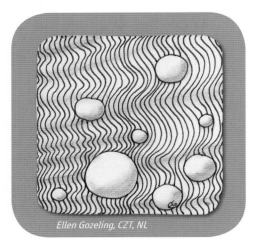

Ellen Gozeling, CZT, NL

I love Nipa because no matter how much I concentrate, I draw the lines different every time. One line follows the other but still each is distinct. Just like waves: They look the same but each one is one of a kind. (Ellen)

I like this pattern because it adds movement and space to the tile. (Tina)

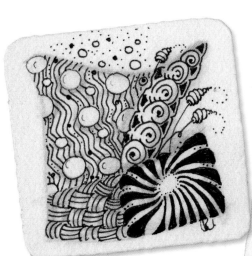

Combination of Nipa, Keeko, Zinger, Printemps, and (Pepper). Beate Winkler, CZT, GER

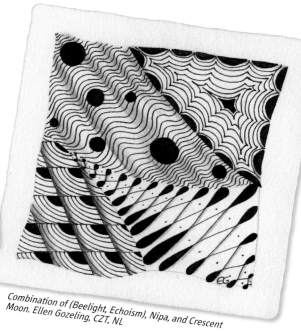

Combination of (Beelight, Echoism), Nipa, and Crescent Moon. Ellen Gozeling, CZT, NL

'Nzeppel (and Random)

Designer: Maria Thomas, Zentangle HQ, USA/MA

 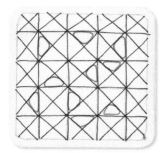

I had never tried this pattern previously, but I fell in love right away with the random variation. It looks beautiful and earthy (almost like cobblestone). (Beate)

'Nzeppel is my favorite pattern because of its versatility. I use it in every size and shape. While you're drawing, it comes to life before your eyes. (Hannah)

Also, I like this pattern because something beautiful and new emerges by doing just small changes to the lines. (Beate)

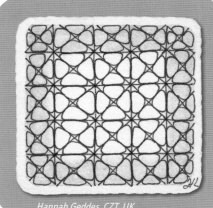

Hannah Geddes, CZT, UK

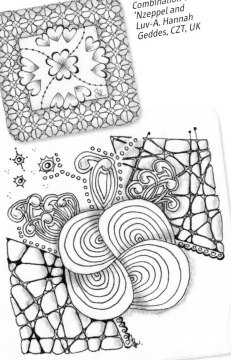

Combination of 'Nzeppel and Luv-A. Hannah Geddes, CZT, UK

 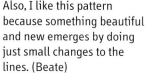

Combination of 'Nzeppel, Mooka, (Thumbprintz), and Widgets. Beate Winkler, CZT, GER

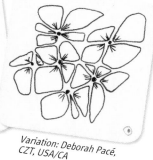

Variation: Deborah Pacé, CZT, USA/CA

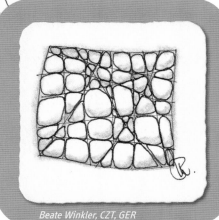

Beate Winkler, CZT, GER

69 Octonet

Designer: Sue Jacobs, CZT, USA/IL

 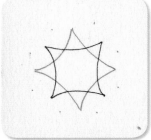 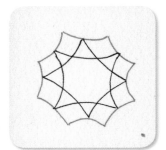 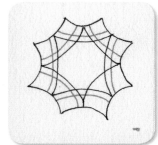

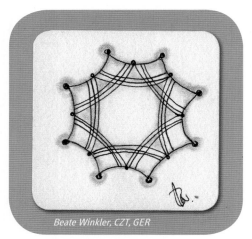

Beate Winkler, CZT, GER

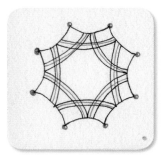

I wanted to add something starry to the book. Octonet is graphically beautiful and interesting to draw, and I went right into the variation, which adds fun. Maybe it is suited for your holiday cards? (Beate)

There are many more star tangles that sparkle. Because we couldn't find out who the designer was, we left out the steps. If somebody knows to whom these two variations Susan tangled belong, we would gladly take the information!

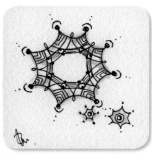

Variation:
Beate Winkler, CZT, GER

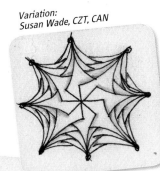

Variation:
Susan Wade, CZT, CAN

Variation:
Susan Wade,
CZT, CAN

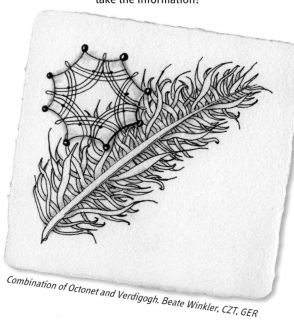

Combination of Octonet and Verdigogh. Beate Winkler, CZT, GER

Designer: Maria Thomas, Zentangle HQ, USA/MA

This is a great pattern for relaxing. The combination of drawing recurring lines to the corners and the turning of the tile after every line creates a very meditative condition. (Sheena)

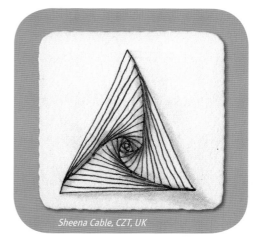

Sheena Cable, CZT, UK

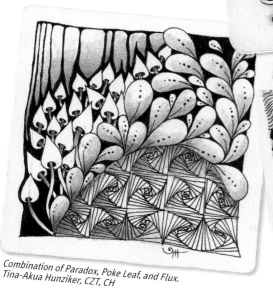

Combination of Paradox and Blooming Butter. Beate Winkler, CZT, GER

Paradox is sometimes called "Rick's Paradox" among CZTs because Rick likes to show great mosaics consisting of only single Paradox tangles, which result in intriguing pictures depending on how they're laid out.

Combination of Paradox, Onamato, Hollibaugh, and Cadent. Sheena Cable, CZT, UK

Combination of Paradox, Poke Leaf, and Flux. Tina-Akua Hunziker, CZT, CH

71 Poke Leaf

Designer: Maria Thomas, Zentangle HQ, USA/MA

 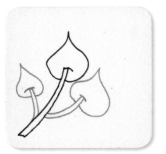 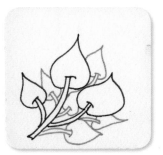

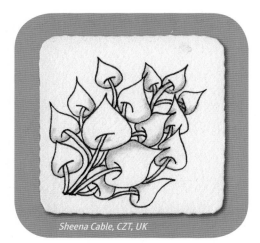

Sheena Cable, CZT, UK

There are many variations of Poke Leaf. (See p. 54, 87, and 111.)

Poke Leaf is very organic and lively. Because it can wrap around other patterns, it is great for filling gaps. (Sheena)

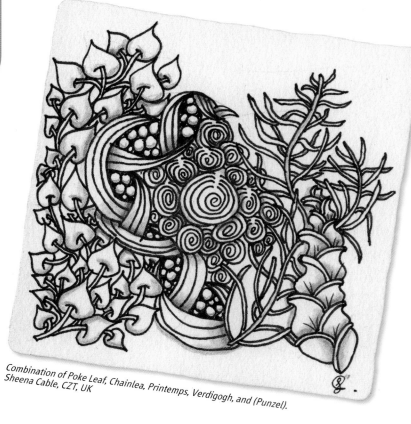

Combination of Poke Leaf, Chainlea, Printemps, Verdigogh, and (Punzel).
Sheena Cable, CZT, UK

Designer: Beate Winkler, CZT, GER

Tip: Always turn the tile so it is easy to draw the lines—i.e., for the second line, turn it 180 degrees.

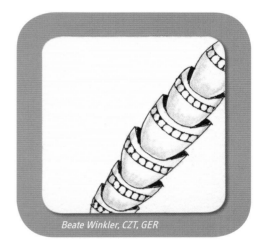

Beate Winkler, CZT, GER

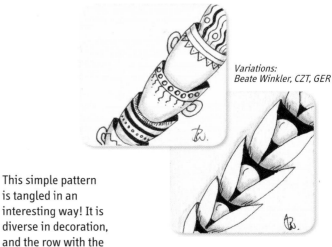

Variations: Beate Winkler, CZT, GER

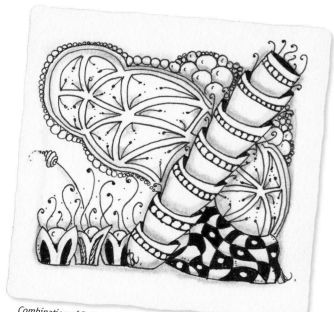

Combination of Potterbee, Tripoli, Fescu, Zinger, Knightsbridge, and (Tipple). Beate Winkler, CZT, GER

This simple pattern is tangled in an interesting way! It is diverse in decoration, and the row with the handles gives it its name. (Beate)

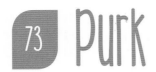

73 Purk

Designer: Rick Roberts & Maria Thomas, Zentangle HQ, USA/MA

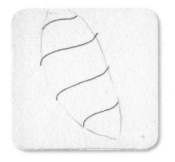
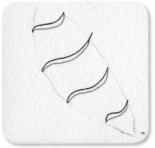

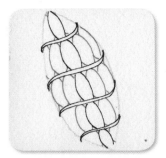

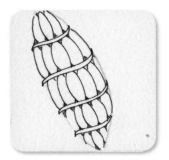
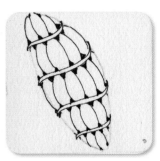

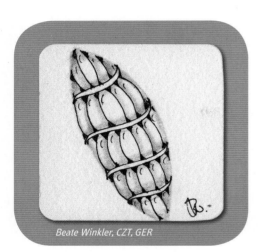

Beate Winkler, CZT, GER

Purk is one of my favorite patterns because with its very simple lines, it emerges as a very organic shape on a piece of paper. The shapes appear magical and alien. (Katie)

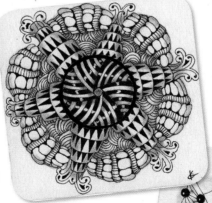

Combination of Purk, M'Spire, Gryst, and Flux. Katie Crommett, CZT, USA/MA

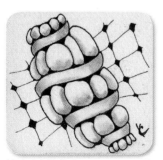

Variation: Katie Crommett, CZT, USA/MA

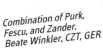

Combination of Purk, Fescu, and Zander. Beate Winkler, CZT, GER

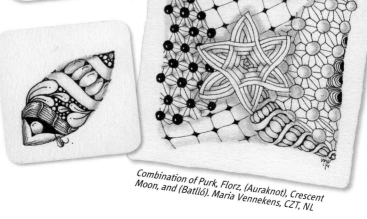

Combination of Purk, Florz, (Auraknot), Crescent Moon, and (Batlló). Maria Vennekens, CZT, NL

Designer: Maiko Y. W. Wong, CZT, CN

 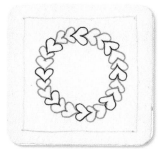

I like this pattern because every heart stands for a dream. From one heart to the next, every dream can become a reality and can lead to a wonderful life. This pattern of hearts makes up a superb crown. (Maiko)

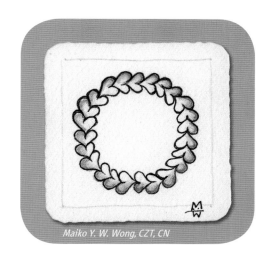

Maiko Y. W. Wong, CZT, CN

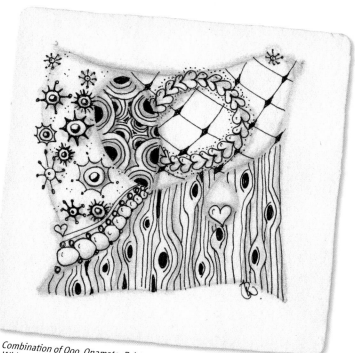

Combination of Qoo, Onamato, B-horn, Crescent Moon, Florz, and Widgets. Beate Winkler, CZT, GER

75 Quare

Designer: Beth Snoderly, USA/WV

 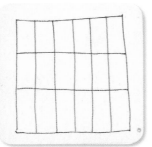 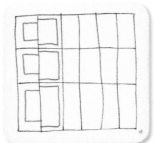 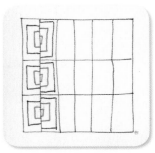

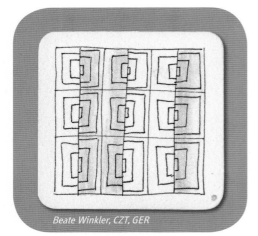

Beate Winkler, CZT, GER

I find Quare funny because it looks like an optical illusion—despite that it is easy to tangle. (Beate)

The shadow makes the difference. Simply color a whole double row with pencil and paper stump gray, leave out the next double row, and then again shade the one after. And suddenly it seems the tangle is bouncing off the page. (Beate)

Variation: Beate Winkler, CZT, GER

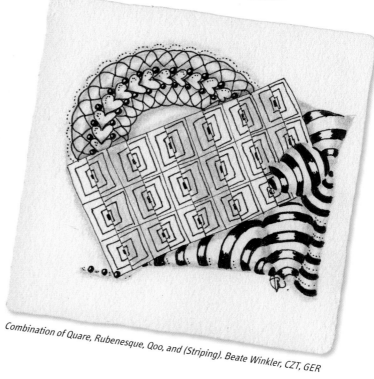

Combination of Quare, Rubenesque, Qoo, and (Striping). Beate Winkler, CZT, GER

Rubenesque

Designer: Hannah Geddes, CZT, UK

I like Rubenesque (which means "strong, beautiful women") a lot because it reminds me of my Spirograph from back in the day. It works as a flower pattern or as a centerpiece. (Hannah)

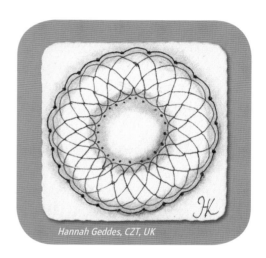

Hannah Geddes, CZT, UK

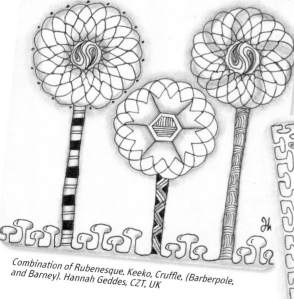

Combination of Rubenesque, Keeko, Cruffle, (Barberpole, and Barney). Hannah Geddes, CZT, UK

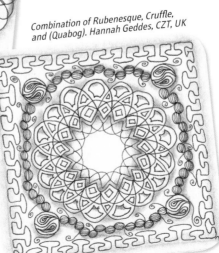

Combination of Rubenesque, Cruffle, and (Quabog). Hannah Geddes, CZT, UK

Variation: Beate Winkler, CZT, GER

77 Sanibelle

Designer: Tricia Faraone, CZT, USA/RI

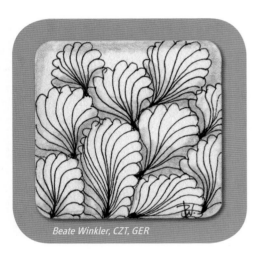

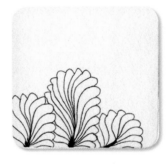

Beate Winkler, CZT, GER

I love Sanibelle because it looks so natural and full. I find the step-by-step instruction all the better: Never would I have thought to start with the top edges. Do you feel the same? (Beate)

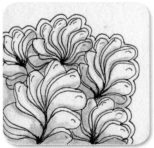

Variation: Beate Winkler, CZT, GER

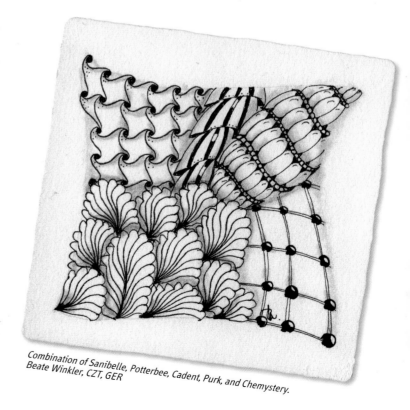

Combination of Sanibelle, Potterbee, Cadent, Purk, and Chemystery.
Beate Winkler, CZT, GER

Designer: Deborah Pacé, CZT, USA/CA

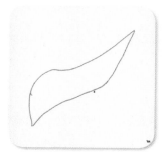
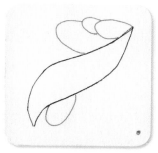

I like this tangle because of its flowing design and because it has a calming effect. And I like how it looks in the end! (Deborah)

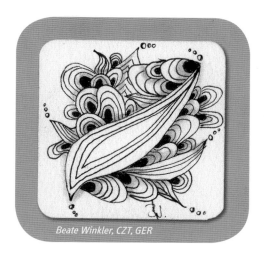

Beate Winkler, CZT, GER

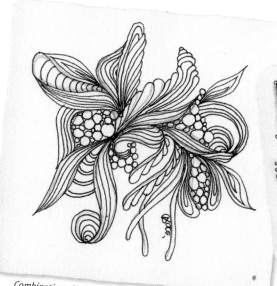

Combination of Sharalarelli, (Tipple), and Aura-Leah.
Deborah Pacé, CZT, USA/CA

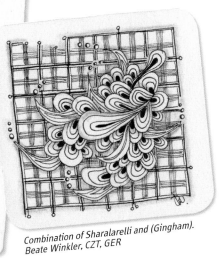

Combination of Sharalarelli and (Gingham).
Beate Winkler, CZT, GER

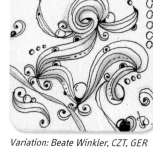

Variation: Beate Winkler, CZT, GER

79 Shattuck

Designer: Rick Roberts & Maria Thomas, Zentangle HQ, USA/MA

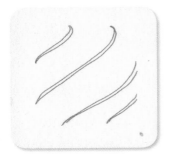
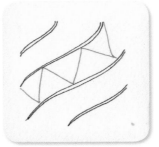
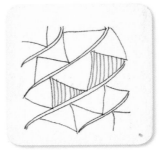
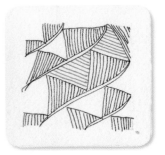

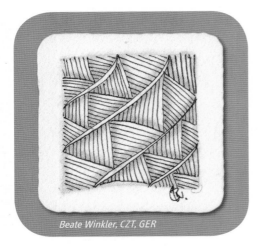

Beate Winkler, CZT, GER

Shattuck is the absolute favorite pattern of many CZTs because on one hand it is artfully alive but also glowing and full. (Beate)

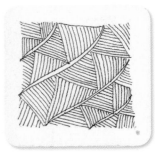

Shattuck is one of my most favorite tangles. It is gallant, calm, and dynamic—simultaneously. And with sparkles (light reflections), it becomes beautifully realistic. (Beate)

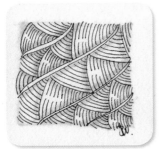

Variation: Beate Winkler, CZT, GER

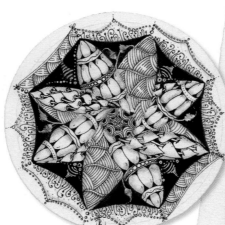

Combination of Shattuck, Purk, Poke Leaf, Fescu, Crescent Moon, and (Indy-Rella). Beate Winkler, CZT, GER

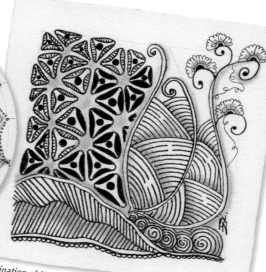

Combination of Shattuck, Tripoli, Henna Drum, (Meer), Printemps, and Trio. Hanny Waldburger, CZT, CH

80 Sundoo

Designer: Jane MacKugler, CZT, USA/VT

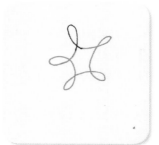
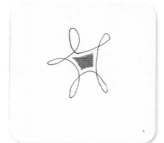
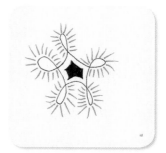

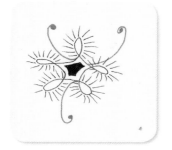

A String can also look this way. How the swooping line should run, to divide the tile, is entirely up to you.

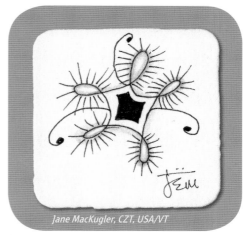

Jane MacKugler, CZT, USA/VT

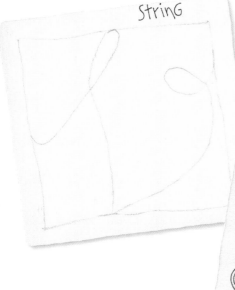

String

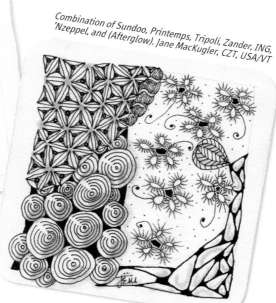

Combination of Sundoo, Printemps, Tripoli, Zander, ING, 'Nzeppel, and (Afterglow). Jane MacKugler, CZT, USA/VT

It reminds me of kayaking between sundew plants, which were the inspiration for this pattern. It is a really happy tangle. (Jane)

81 Sweda

Designer: Maria Vennekens, CZT, NL

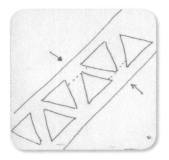
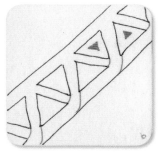
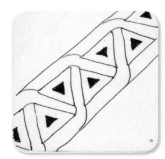

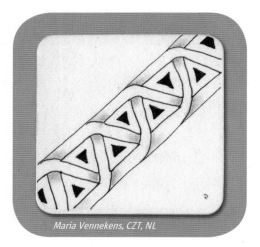

Maria Vennekens, CZT, NL

Because of our enthusiasm when we create new patterns it can happen that we run wild. Instead of two to six steps we may end up with ten! Such is the case with Hanny's new beautiful pattern Trio.

I found the inspiration for this pattern in a songbook. It was depicted as a border next to a song from Sweden. (Maria)

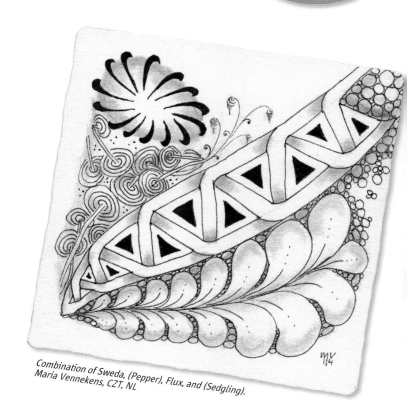

Combination of Sweda, (Pepper), Flux, and (Sedgling).
Maria Vennekens, CZT, NL

Designer: Hanny Waldburger, CZT, CH

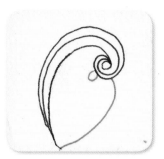

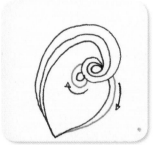
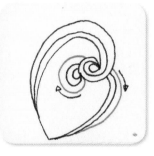
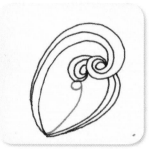
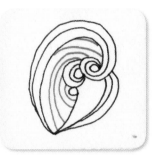

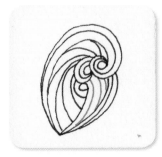

Trio is my favorite pattern because it is my own creation and came out of nothing. It mirrors my style and my excitement about dynamic and curved lines and shapes. While drawing Trio, I really come to life. It makes for good combinations with any nature patterns (i.e., Verdigogh). (Hanny)

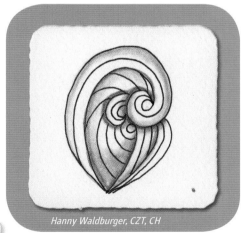

Hanny Waldburger, CZT, CH

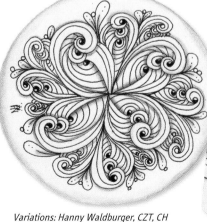
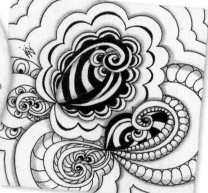

Variations: Hanny Waldburger, CZT, CH

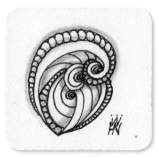

Variation: Hanny Waldburger, CZT, CH

Tri-Po

Designer: Sue Clark, CZT, USA/CO

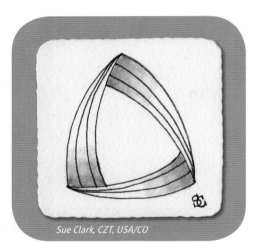
Sue Clark, CZT, USA/CO

I like Tri-Po because it is easy to draw considering the repetition of the same line and yet it still looks sensational. (Sue)

Tip: The pattern can stand on its own or it can border or cross over other patterns.

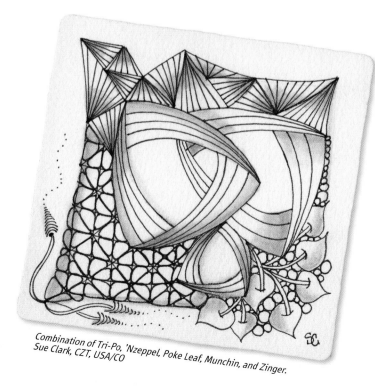
Combination of Tri-Po, 'Nzeppel, Poke Leaf, Munchin, and Zinger.
Sue Clark, CZT, USA/CO

Designer: Rick Roberts & Maria Thomas, Zentangle HQ, USA/MA

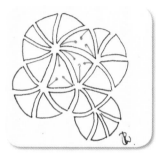

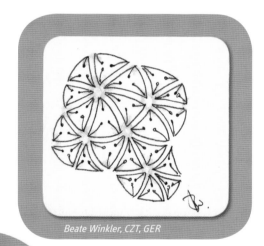

Tripoli is one of my favorite patterns because it has infinite possible variations and because the space between the lines is what makes it up. (Hanny)

Beate Winkler, CZT, GER

Molly said she holds workshops that involve only the Tripoli pattern. I can understand that well. (Beate)

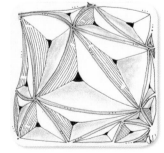

Variation: Beate Winkler, CZT, GER

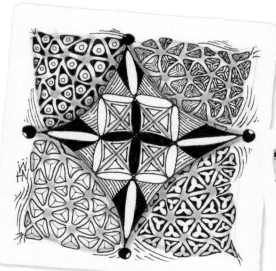

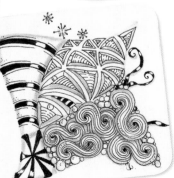

Combination of Tripoli, Goldilocks, Bunzo, and (Pepper). Beate Winkler, CZT, GER

Combination of Tripoli and Fjura. Hanny Waldburger, CZT, CH

Tropicana

Designer: Kate Ahrens, CZT, USA/MN

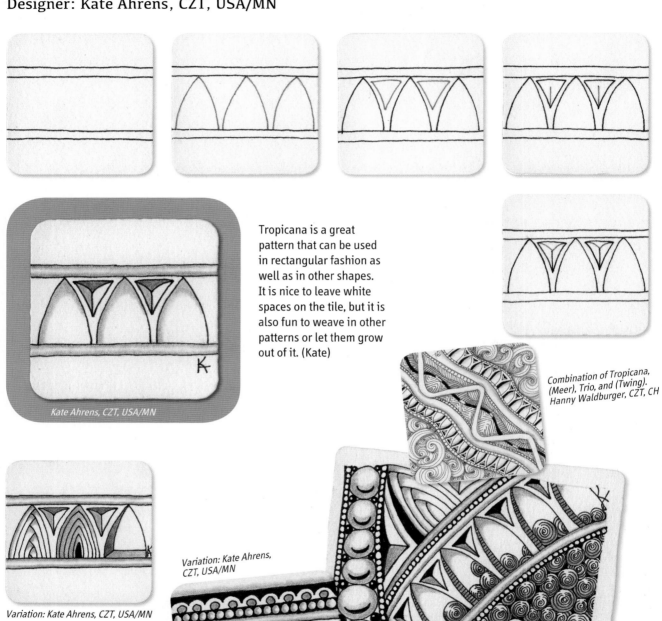

Tropicana is a great pattern that can be used in rectangular fashion as well as in other shapes. It is nice to leave white spaces on the tile, but it is also fun to weave in other patterns or let them grow out of it. (Kate)

Kate Ahrens, CZT, USA/MN

Variation: Kate Ahrens, CZT, USA/MN

Variation: Kate Ahrens, CZT, USA/MN

Combination of Tropicana, (Meer), Trio, and (Twing). Hanny Waldburger, CZT, CH

Combination of Tropicana, Onamato, Printemps, and (Betweed). Kate Ahrens, CZT, USA/MN

Designer: Stella Peters-Hessels, CZT, NL

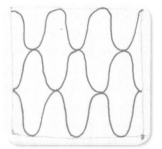 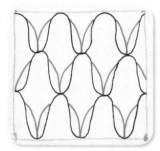 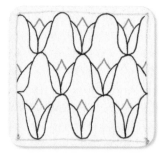

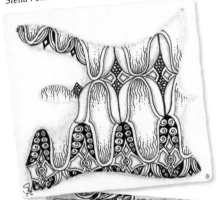

Combination of Tulipe, Msst, and Printemps.
Stella Peters-Hessels, CZT, NL

This tangle was a surprising and unplanned result while trying a different pattern. I thought it looked like a Dutch tulip and therefore gave it the French name "Tulipe." (Stella)

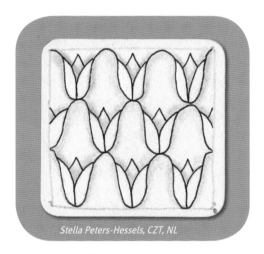

Stella Peters-Hessels, CZT, NL

Variations:
Stella Peters-Hessels, CZT, NL

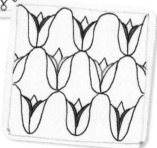

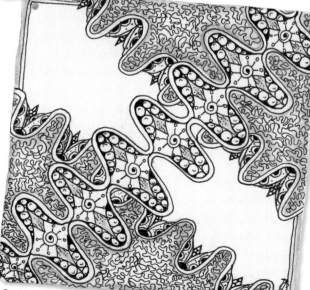

Combination of Tulipe and (Amaze). Stella Peters-Hessels, CZT, NL

87 Twenty-One

Designer: Mariët Lustenhouwer, NL

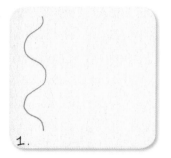

1.

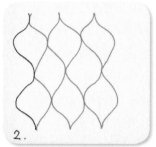

2.

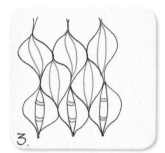

3.

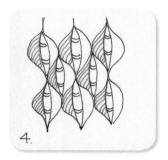

4.

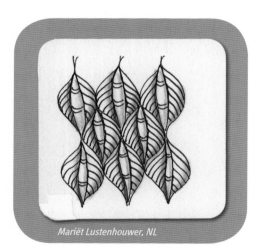

Mariët Lustenhouwer, NL

Combination of Twenty-One and Onamato. Diana Schreur, CZT, NL

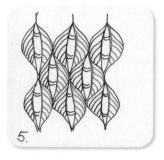

5.

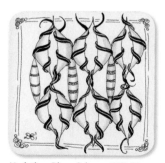

Variation: Diana Schreur, CZT, NL

Because of its many variations, Twenty-One has many faces. (Diana)

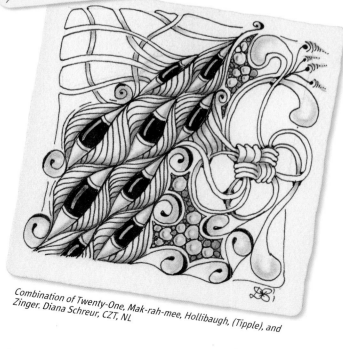

Combination of Twenty-One, Mak-rah-mee, Hollibaugh, (Tipple), and Zinger. Diana Schreur, CZT, NL

Designer: Joyce Block, CZT, USA/WI

Wheelz is like a washer with too much detergent—it slowly but surely will overflow. You won't want to stop. On every small corner, you can add another String through tangling. (Beate)

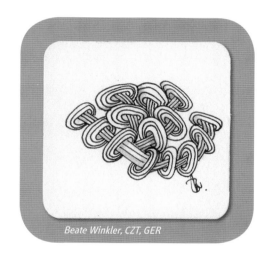

Beate Winkler, CZT, GER

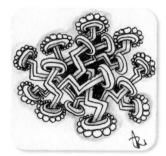

Variation: Beate Winkler, CZT, GER

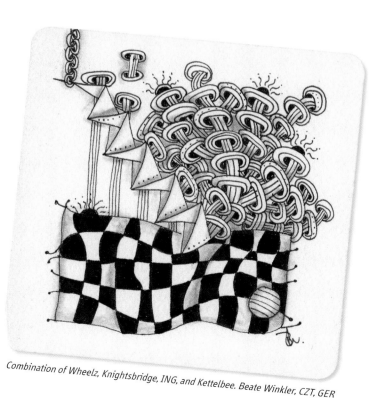

Combination of Wheelz, Knightsbridge, ING, and Kettelbee. Beate Winkler, CZT, GER

89 Wiking

Designer: Arja de Lange-Huisman, CZT, NL

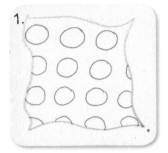
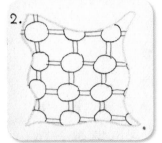
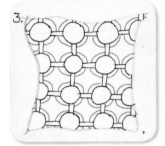
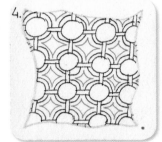

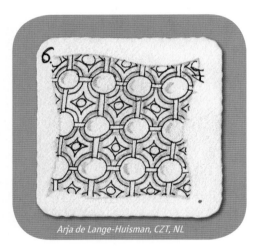

Arja de Lange-Huisman, CZT, NL

I like this pattern because I found it on a real Viking brooch that I saw in Denmark during the summer. It offers a great number of possibilities to be changed up by adding shades, tints, and highlights. (Arja)

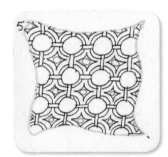

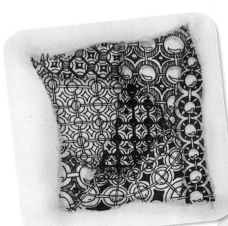

Variation:
Arja de Lange-Huisman, CZT, NL

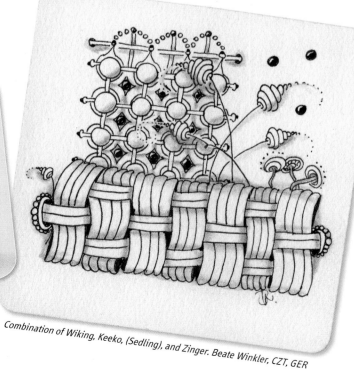

Combination of Wiking, Keeko, (Sedling), and Zinger. Beate Winkler, CZT, GER

Designer: Rick Roberts & Maria Thomas, Zentangle HQ, USA/MA

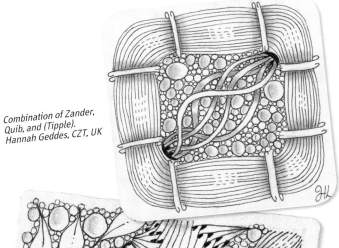

Combination of Zander, Quib, and (Tipple). Hannah Geddes, CZT, UK

Hannah Geddes, CZT, UK

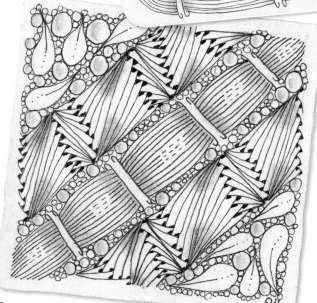

Combination of Zander, (Betweed), and Flux. Hannah Geddes, CZT, UK

Variation: Beate Winkler, CZT, GER

Zander can be used as a frame or divider. Whether it is thin or wide, it adds nice dimensions to the paper. (Hannah)

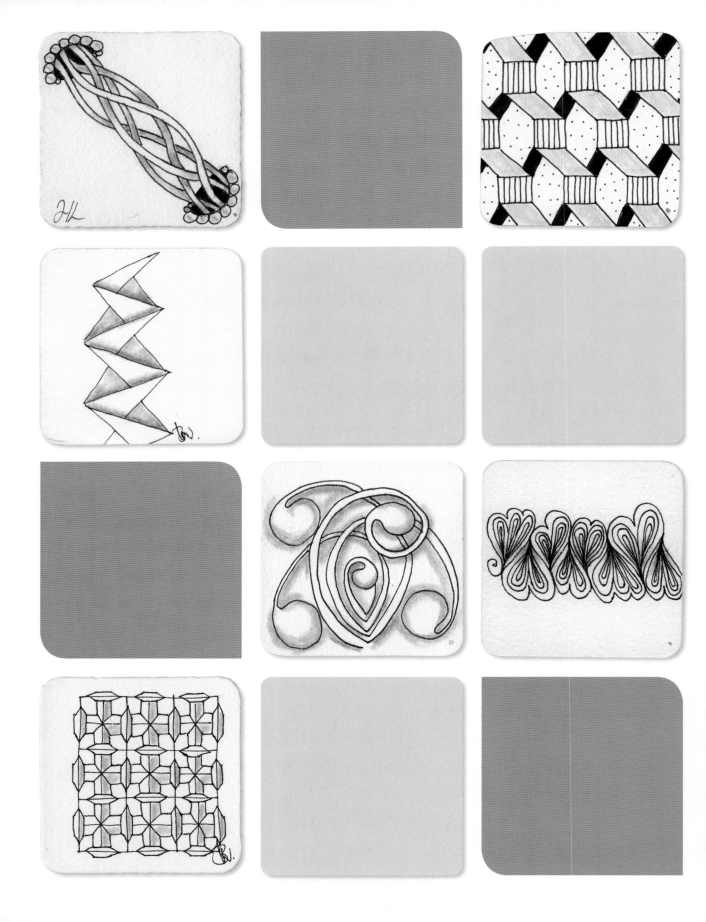

Tangles for the Master Class

You should try these tangles calmly and individually—they're very effective. In the beginning, you might puzzle over some, but once the tangle is successfully finished, you will be proud of it!

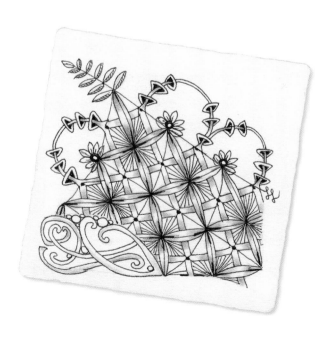

Quib

Designer: Rick Roberts & Maria Thomas, Zentangle HQ, USA/MA

 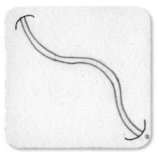 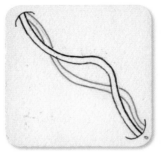 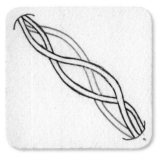

I love Quib because it is flowing and free. You need a few preliminary considerations for drawing the tentacles above and below. But in the end it looks really fabulous. (Hannah)

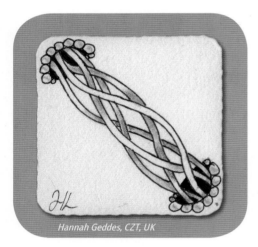

Hannah Geddes, CZT, UK

Combination of Quib, 'Nzeppel, and (Tipple). Hannah Geddes, CZT, UK

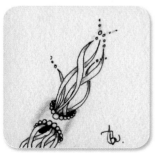

Variation: Beate Winkler, CZT, GER

For Quib, you have to take a good look at everything that goes above and below. And once combined with black or Tipple, it really impresses. (Beate)

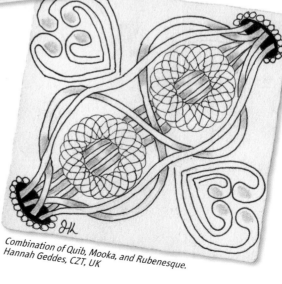

Combination of Quib, Mooka, and Rubenesque. Hannah Geddes, CZT, UK

Designer: Conny Holsappel, NL

Tip: Mark the grid with pencil.

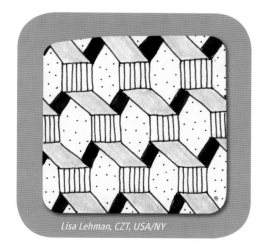

Lisa Lehman, CZT, USA/NY

Casella has a lot of steps. You should really do one at a time so you don't get confused. (Beate)

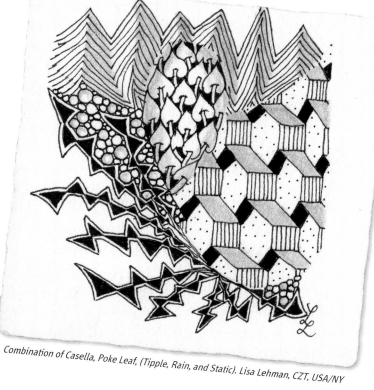

Combination of Casella, Poke Leaf, (Tipple, Rain, and Static). Lisa Lehman, CZT, USA/NY

Galileo

Designer: Sue Jacobs, CZT, USA/IL

 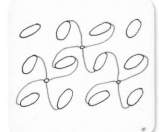 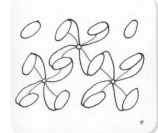

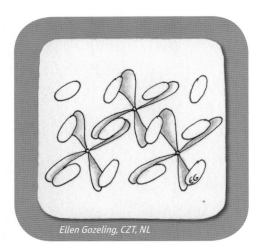

Ellen Gozeling, CZT, NL

The name alone caught my attention. The pattern is harder than it looks (with most, it is the other way around). So simply try it out and relax into it. (Beate)

Variation: Ellen Gozeling, CZT, NL

I love the tangle Galileo because it holds my focus and it has a lot of movement. (Ellen)

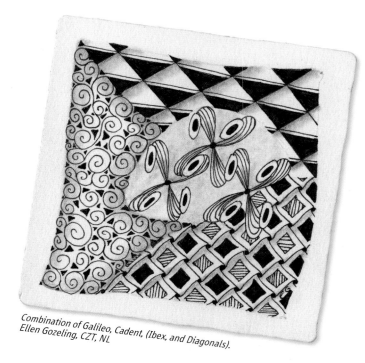

Combination of Galileo, Cadent, (Ibex, and Diagonals). Ellen Gozeling, CZT, NL

94 Verdigogh

Designer: Maria Thomas, Zentangle HQ, USA/MA

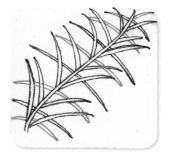

I like Verdigogh because it reminds me of nature. (Marty)

For impatient people like me this tangle is a challenge. But if I concentrate on one line at a time I notice how the calm comes over me. And I'm pleased at how simply the beautiful pattern comes to life. (Beate)

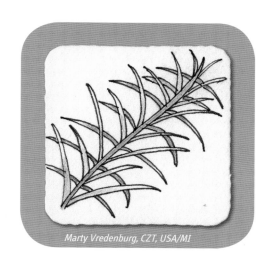

Marty Vredenburg, CZT, USA/MI

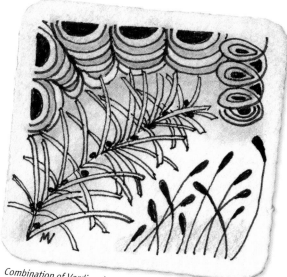

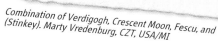

Combination of Verdigogh, Crescent Moon, Fescu, and (Stinkey). Marty Vredenburg, CZT, USA/MI

Variations:
Beate Winkler, CZT, GER

Verdigogh likes to be on its own once in a while as a monotangle.

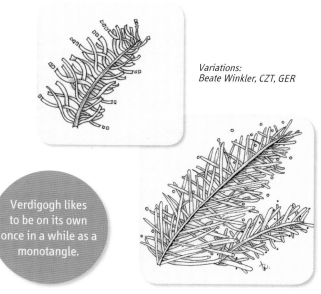

95 Impossible Triangle

Designer: Maria Thomas, Zentangle HQ, USA/MA

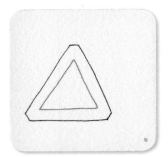

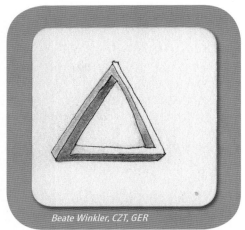

Beate Winkler, CZT, GER

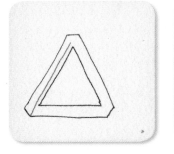
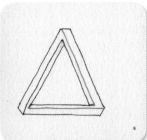

Swedish artist Oscar Reutersvärd first created the Penrose triangle, or Tribar, in 1934. Exactly twenty years later the mathematician Roger Penrose, who also named it, discovered it again. Inspired by drawings by M. C. Escher, he attempted to create impossible figures. He had the most obvious success with Tribar.

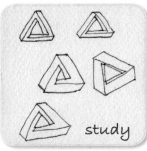

Study: Beate Winkler, CZT, GER

I have meticulously worked out five different instructions and hope that this step-out will help you. (Beate)

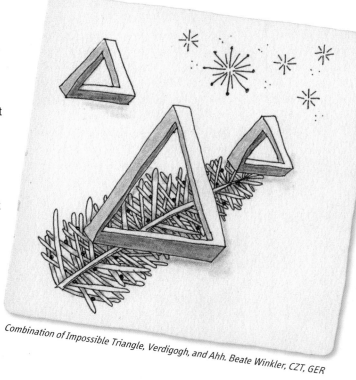

Combination of Impossible Triangle, Verdigogh, and Ahh. Beate Winkler, CZT, GER

Designer: Sandy Hunter, CZT, USA/TX

 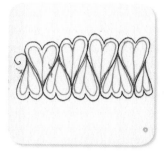 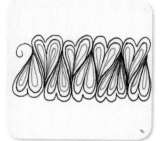 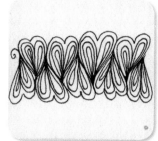

Puffle requires some practice. Pay attention so that the lines are touching. When filling, always start from the middle and nestle the edges up against each other; otherwise, it will lose the 3D effect. (Beate)

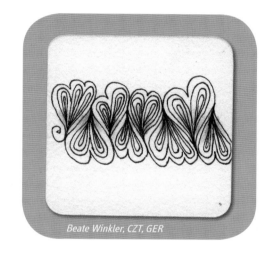

Beate Winkler, CZT, GER

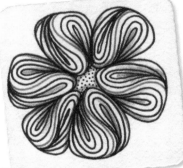

Variation:
Sandy Hunter,
CZT, USA/TX

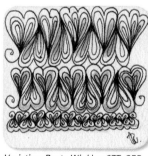

Variation: Beate Winkler, CZT, GER

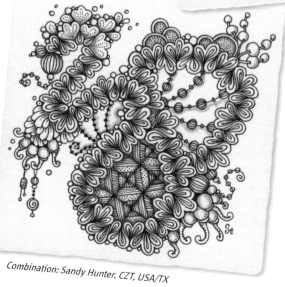

The pattern looks loose and simple and it makes me marvel. For the step-out, I needed a few attempts, so please take a close look and you'll succeed more easily. (Beate)

Combination: Sandy Hunter, CZT, USA/TX

Crux

Designer: Henrike Bratz, GER

 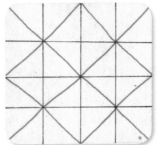 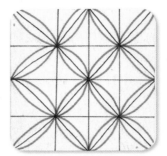 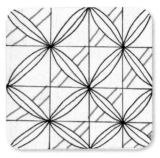

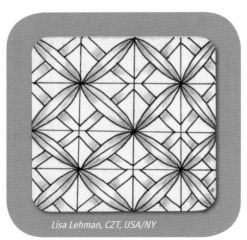

Crux reminds me of Fife, by Rick and Maria, but the journey is very different. Once again, it appears that the difference is in the detail. (Beate)

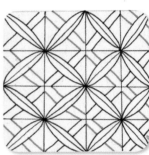

Lisa Lehman, CZT, USA/NY

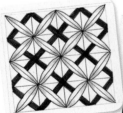 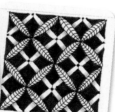

Variations:
Lisa Lehman, CZT, USA/NY

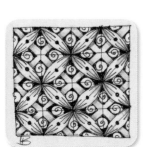

Variation: Henrike Bratz, GER

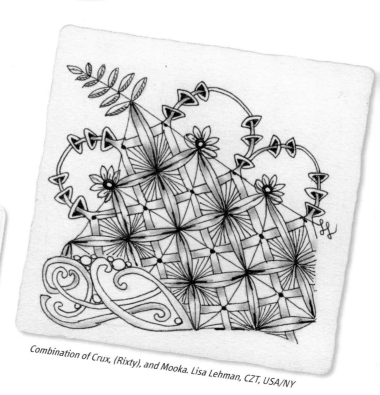

Combination of Crux, (Rixty), and Mooka. Lisa Lehman, CZT, USA/NY

Designer: Molly Hollibaugh, Zentangle HQ, USA/MA

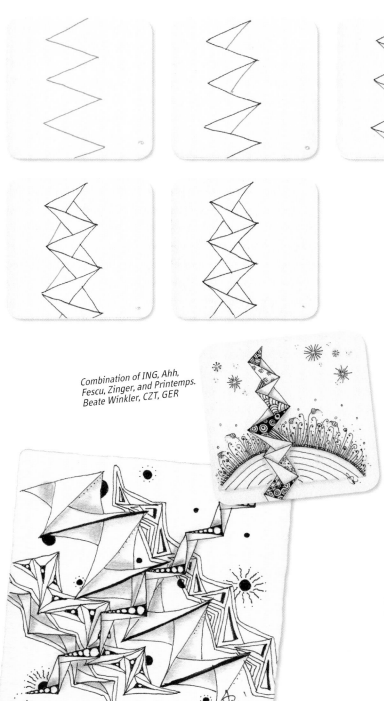

Combination of ING, Ahh,
Fescu, Zinger, and Printemps.
Beate Winkler, CZT, GER

Variations: Beate Winkler, CZT, GER

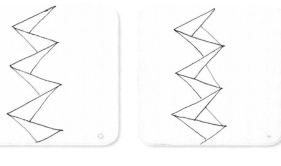

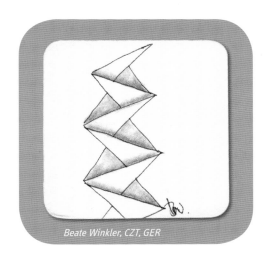

Beate Winkler, CZT, GER

I love ING. It is the newest tangle from the Zentangle HQ, introduced during summer 2014. Thanks to its large variety, it found many fans immediately. I especially like the origami look and feel. (Beate)

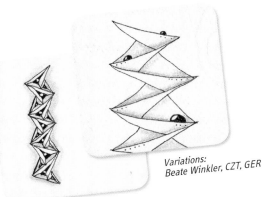

Variations:
Beate Winkler, CZT, GER

99 Zenplosion Folds

Designer: Daniele O'Brien, CZT, USA/MI

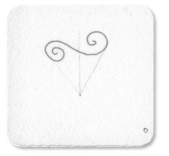 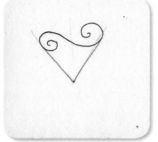 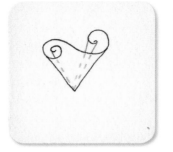 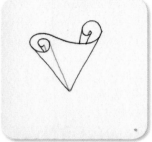

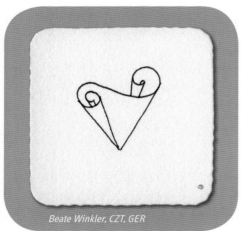

Beate Winkler, CZT, GER

If you let the lines come together at the right angle, Zenplosion Folds is very dynamic and prominent on the tile. I like it very much, especially because it is super-easy and fast to draw. (Beate)

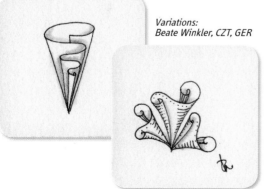

Variations:
Beate Winkler, CZT, GER

Variation Coneflor:
Susan Wade, CZT, CAN

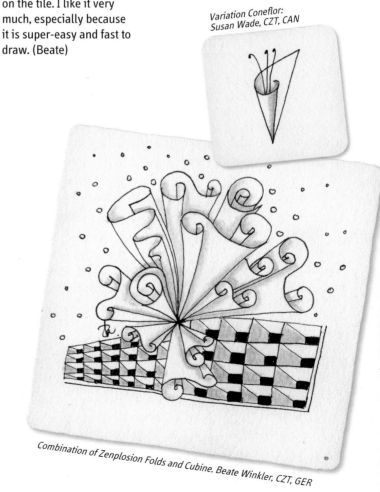

Combination of Zenplosion Folds and Cubine. Beate Winkler, CZT, GER

Designer: Wayne Harlow, CZT, USA/CA

Tip:
For every step, turn the tile three times until all steps are easy to tangle.

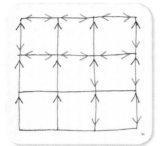
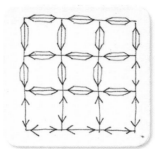
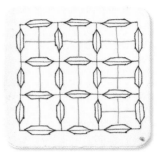

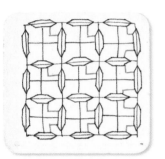
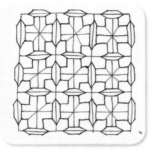

Crusade has been the biggest challenge yet. When I saw it, I liked it right away. And then I wanted to learn it and had to take many different routes. (Beate)

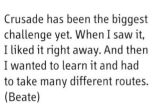

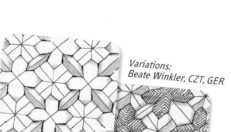

Variations:
Beate Winkler, CZT, GER

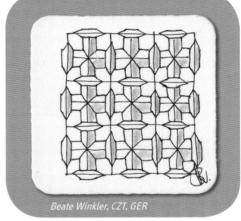

Beate Winkler, CZT, GER

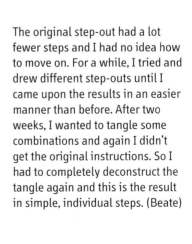

The original step-out had a lot fewer steps and I had no idea how to move on. For a while, I tried and drew different step-outs until I came upon the results in an easier manner than before. After two weeks, I wanted to tangle some combinations and again I didn't get the original instructions. So I had to completely deconstruct the tangle again and this is the result in simple, individual steps. (Beate)

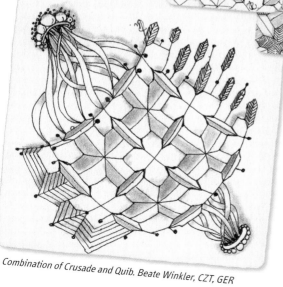

Combination of Crusade and Quib. Beate Winkler, CZT, GER

Mooka (unfurled)

Designer: Maria Thomas, Zentangle HQ, USA/MA

 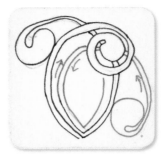 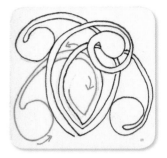

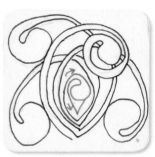

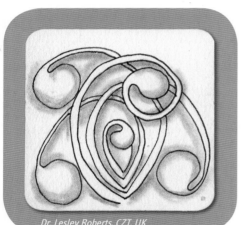

Dr. Lesley Roberts, CZT, UK

Here are some nice examples for adding different kinds of shadows.

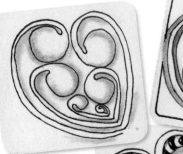 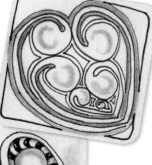

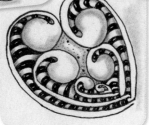

Infurled variations: Dr. Lesley Roberts, CZT, UK

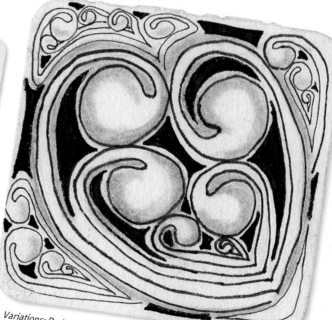

Variations: Dr. Lesley Roberts, CZT, UK

1

2

3

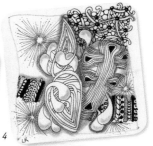

4

5

I end this section of tangles with Mooka, a tangle with a great story.
Maria was inspired by the famous Art Deco poster painter Alphonse Mucha (1860–1939) and drew Mooka the way it looks on the first tile. (1)

To me it always looked boring and a little tired. When I was at the CZT-Europe Meeting sitting next to Lesley, I saw how beautifully she drew her Mookas and how much power and dynamic energy they radiated. She explained in great detail her story about "the struggles along the journey to Mooka." Ever since then, I have called her "The Mooka Lady." She is the first person I asked to participate in this book.

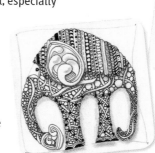

6

"In the beginning I found no enjoyment in Mooka; it was stubborn and it never developed in the direction I wanted. I found it ugly and just wasn't happy with the look of it, especially not with the 'leaves.' When I taught this tangle to my students, they were just as frustrated as I, but Claire decided to practice. That inspired me to do the same! When I started to practice, always one stroke after the other, I slowly developed a technique for drawing Mooka and found it suddenly a lot more appealing. Claire went through the same and today she is happy with her beautiful Mooka tangles. Meanwhile, I have reached a point where I truly enjoy drawing Mookas. I draw them everywhere: in my daily planner, on pebbles at the beach in Greece, on my business cards and flyers, on tiles in black and white and even in color. I hope this story inspires you to practice Mooka, because it will need practice if you want to draw it well." (Lesley)

7

8

9

10

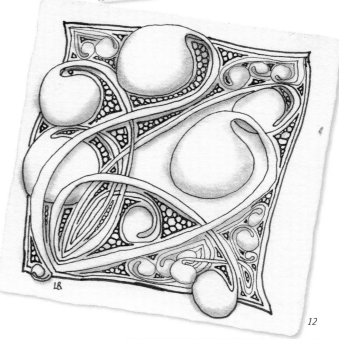

11

12

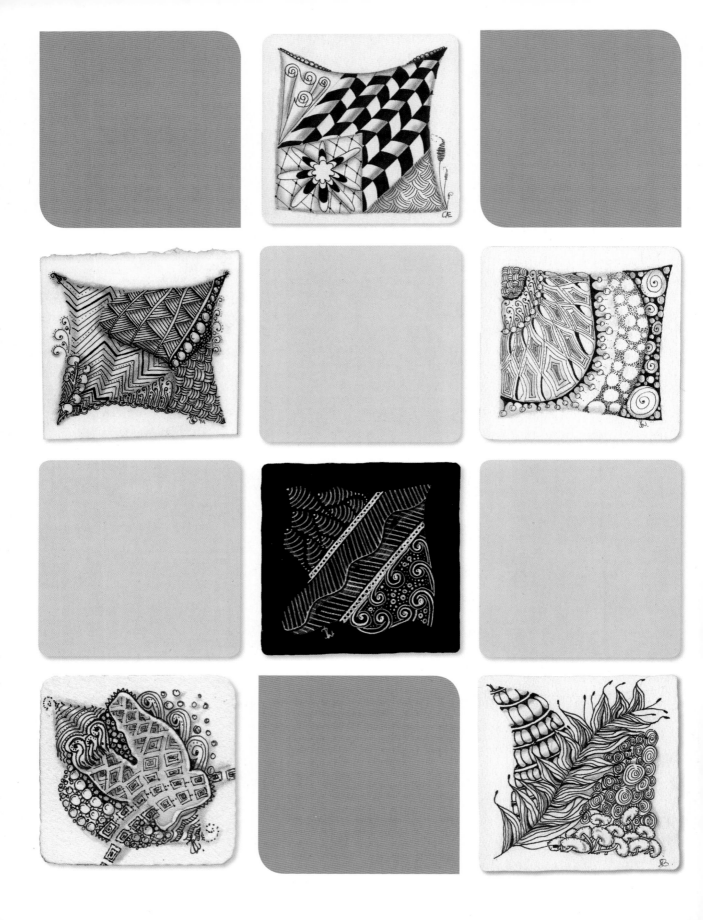

Good to Know

In this chapter, you'll receive a deeper insight into the subject of Zentangle. Questions will be answered and there are tips for everyone who wants to keep tangling and wants to venture into new materials. Technical terms will be explained, and you'll find all tangles from A to Z again on pages 140–143.

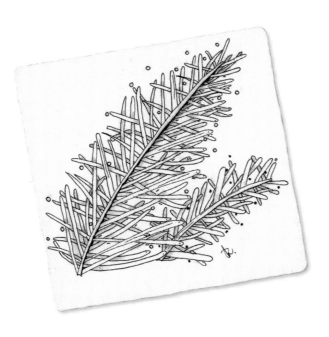

Questions and Answers

"Will I find tangling too difficult, especially if I can't draw?"

Zentangle is simple! I promise. You don't need to be able to draw when you're starting out.

In fact, you don't need any artistic knowledge or special drawing talent. And if you do have it: congratulations! Zentangle is highly interesting for artists as well.

It has been said that most people stop drawing at nine years old. After that they usually decide not to keep drawing and focus their attention on something else. That's why many pictures come out looking childlike when years later we try to draw. You'll just need some practice, just like roller-skating or crocheting. Therefore, don't panic; everybody can draw these beautiful patterns. Simply turn off the self-critical part of the brain, take a deep breath, open your eyes, take a careful look at the step-by-step instructions, and let's go!

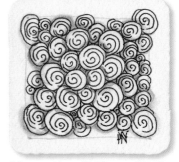

Printemps. Hanny Waldburger, CZT, CH

"How can something that looks so complex be so simple to draw?"

When you look at it closely you'll notice that the tangles consist of a few very simple, repeated single lines.

Anybody who can hold a pen can draw them. It is as simple as drawing a stick figure. Give yourself some time. Play with the pattern.

"But aren't these just doodles?"

The comparison is close because tangling is actually as simple as the phone and math notebook doodles that are often created accidentally and maybe even unconsciously out of boredom.

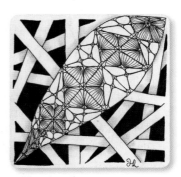

*Hallibough and 'Nzeppel.
Hannah Geddes, CZT, UK*

Zentangle is the exact opposite of that, though: It is a very conscious, careful, and focused activity. That's the reason why Zentangle is so relaxing.

It is just like cooking: You can either heat up a can of ravioli and be unhappy after eating, or you can take part in a ritual that celebrates the art of cooking with fresh ingredients from the market and enjoy the feast. But compared to cooking, you need less time and materials for Zentangle and you will obtain a result to treasure and keep—with zero calories.

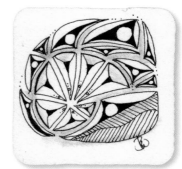

Tripoli and (Meer). Beate Winkler, CZT, GER

"What should my tangles look like?"

Tangles are supposed to be abstract. They should have structured patterns that depict no representational shapes. While tangling, we don't have to think about it or try tensely to copy something real. Therefore, there are no mistakes!

Of course the temptation is there to pick from something we know, to find a docking point from a picture in the real world. Association creates an overview. We like to grasp from experience; it provides us with security. That's why children step into anything new without restraint. They simply try it, because logically they're inexperienced, which could prevent them from doing so. Trust and give in to this process, take a deep breath, and just draw line by line by line. Relax. No matter what the result is, it most certainly will be a tangle.

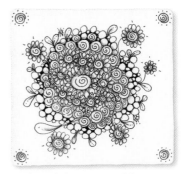

Purrlyz and Flux. Hanny Waldburger, CZT, CH

Tangle names are also abstract, fantasy creations. But of course here too the brain, grasping for experience, will try to sneak in, thinking of the tangle as a representation of something concrete. It is okay to do this. It helps us remember a pattern. Familiarity calms, especially if they're favorite patterns.

"What if I can't even draw a straight line?"

For me it is a challenge to draw a long straight line. The same goes for circles. Often it turns more into an egg when I draw it in one motion. Maria Thomas has a tip: "Draw the most beautiful, roundest circle that you can image in this particular moment," and then maybe right next to it goes the next roundest circle you can draw in that moment.

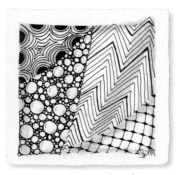

Crescent Moon, Florz, Static, and (Tipple). Beate Winkler, CZT, GER

The pleasant thing about Zentangle is that it should look hand drawn; it is nicely organic, natural, and lively. Please do not use a ruler or circle template. Take a deep breath and just start drawing. Any result will be great! It is your work, and you just created it. Maybe tomorrow you'll create a new one.

"Why do I relax while tangling?"

Often we hear "Don't worry!" and "Forget about your worries." But how? Don't think about the white elephant—this prompt is impossible, for if we try to perform this task, not to think about it right now, it stands mentally right in front of us.

But when you shift all your concentration to the simple principle "line by line by line," you'll give yourself a break from pondering, and you'll gain distance and start to relax. This is Zentangle.

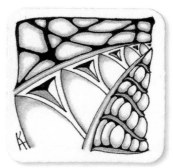

Tropicana, 'Nzeppel-Random, and Purk. Kate Ahrens, CZT, USA/MN

The modern person has found a new vice: speed.

—*Aldous Huxley*

Good Reasons to Zentangle

Because of it, many people can:

- relax

- take a time-out

- creatively submerge

- work off stress

- quiet the noise of the mind

- improve hand-eye coordination

- develop a feeling of inner peace

- learn awareness and focus

- improve personal well-being and confidence

- develop a feeling of capability, satisfaction, and trust

- increase concentration

- create a haven for letting the soul tinker

- calm their heart rate

- lower blood pressure

- fall asleep easier and awake refreshed

- sharpen vision and perceive the environment in more detail

- feel more creative

- be glad about doing something artistic

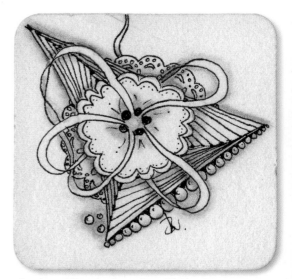

Paradox and Blooming Butter. Beate Winkler, CZT, GER

What Zentangle can achieve

- A Zentangle study by Meredith Yuhas, PhD, found that Zentangle can relieve stress and fear, ease pain, promote creativity, and bring calm and focus. Read more: ww2.usj.edu/PDF/zentangle-survey-results.pdf

- According to Csikszentmihalyi (1996) often during a creative process, a special state of mind—a kind of trance—occurs that is usually identified as flow and mostly appears as a temporary forgetting of time. The feeling is being simultaneously concentrated and relaxed.

- For some creative activities (i.e., delicate bead threading work) I have to have patience. With Zentangle, the time span, location, and emotional state don't matter. It enriches me, it gives me patience (i.e., if I have to sit in a waiting room). It creates calm and relaxes me.

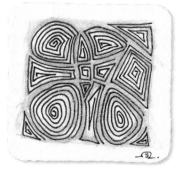

(Courant). Stephan Chan, CZT, CN

"Why is it important to promote our creativity?"

- "The question is not if we are or are not creative; all people are creative." As Joy Paul Guilford says, creativity is something we're born with. The only important questions are whether we have been able and were allowed to try it out, and when and how we took the time and space for it.

- Simply put, creativity emerges mostly from our right, creative half of the brain. In our society, though, the left, rational half of the brain (responsible for logical thinking, numbers, and verbal language) is mostly promoted. That's why we are very rarely creative. Since we can't test out and train our creativity, we think we can't be creative. And so begins the vicious cycle: Because we think we're not creative, we don't even try.

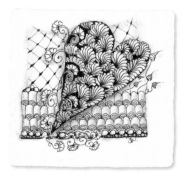

Sanibelle, Logjam, Henna Drum, Florz, and Zinger. Beate Winkler, CZT, GER

- Zentangle has been successfully applied in schools as well as in rehabilitation and hospital settings, and it can be helpful for treating ADD/ADHD and pain.

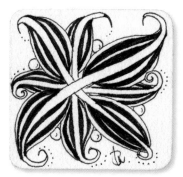

(Squill). Beate Winkler, CZT, GER

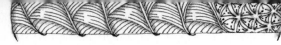
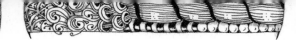

Technical Terms

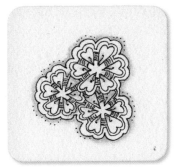

Herzlbee: Enhancement using Aura, Perf, and Shading

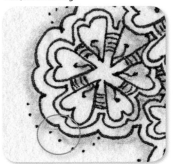

Perf

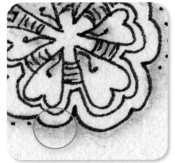

Aura

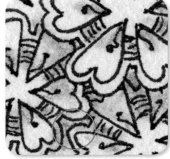

Shading

Technical Term	Meaning
2"	2" (5 x 5 cm) measurement of Bijou tile.
3½"	3½" (9 x 9 cm) measurement of official tile.
Aura	One of six possible simple tangle enhancements: one or more lines are drawn closely around a pattern to add steadiness and shine. For example, "Winkbee" would look faded without Aura.
Bijou	The new, second official tile format is cute and small at 2" (5 x 5 cm).
Blender	Or blending stump = paper stump.
Border	Frame, edge, braid, trim.
Certified Zentangle Teacher (CZT)	A teacher who successfully finished a training course held by Rick and Maria and therefore is qualified to teach the Zentangle method.
Contrast	Sharp difference between two adjacent patterns.
CZT	Abbreviation for Certified Zentangle Teacher.
Deconstructing	A pattern is deconstructed, meaning taken apart into single steps and line sequences to be used for building a tangle.
Dewdrop	One of the six tangle enhancements for advanced tanglers: a circle is drawn onto the tile, then a complete pattern is tangled. At the end, like with a dewdrop, the pattern within the circle is highlighted and outlined with a shadow.
Doodle	Simple scribble.
Enhance	To highlight or reinforce. For Zentangle, it means the six tangle enhancements.
Mandala	From the Sanskrit: circle. Painting colorful Mandala patterns has been used for meditation for a long time. Zentangle has also the relaxing impact but is more diverse.
Monotangle	Tangle design consisting of only one pattern.
Mosaic	Several tiles combined to create a larger piece of art.
Paper stump	A pen made of soft paper that is tightly wound, used for detailed smudging of pencil lines for shading.
Pattern	When talking within the theme of Zentangle, we mean a specific tangle.
Pearl	Shading a circle so that it appears 3D, just like a pearl.
Perfs	One of the six tangle enhancements, consisting of tiny pearl circles, which are added around the tangle. For example, the tangle "Quipple" consists only of such pearl circles.
Rounding	One of the six tangle enhancements, when lines run together or when corners are retraced with a fine-liner. "Paradox" and "Sanibelle" are nice examples.

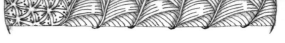

Technical Term	Meaning
Shading	To add shade to the finished tangle with a pencil so it appears livelier and 3D.
Sparkle	One of the six tangle enhancements: when drawing a line, swoop, or circle you'll leave a gap, "pause," and after a little bit of distance the line continues; this gives the illusion of highlights. "Printemps" and "Shattuck" are good examples.
Step-by-step	Another word for step-out (step-by-step instruction).
Step-out	A step-by-step explanation of the construction of a tangle.
String	The line for the basic division of a tile. It can be swooping and drawn differently every time.
Stroke	Line.
Swap	Exchange forum for tangles.
Tangleation	Combination of "tangle" and "variation."
Tangle	A pattern with its own name, consisting of simple and repeating lines.
To tangle	The drawing of patterns.
Tangle-enhancer	The six basic techniques to embellish a tangle: Aura, Dewdrop, Perfs, Rounding, Shading, and Sparkle.
Tangler	Somebody who draws tangles.
Tango	Two or more patterns so interwoven that it looks as if they're dancing with each other (i.e., the step-out of "Cadent" with "MI2").
Tile	A 3½" (9 x 9 cm) paper card—the official size for drawing a tangle within minutes. In June 2014, the smaller 2" (5 x 5 cm) format Bijou was added as the second official tile.
Tortillion	Zentangle Inc. loves this French term for paper stump.
Zendala	4½" (11.2 cm) round. Official Zentangle tile based on Mandala.
Zendoodle	Two-dimensional scribbles with a hint of meditation.
Zentangle	Through the drawing of structured patterns emerge beautiful graphic, 3D pictures with spatial depth. The Zentangle method is simple to learn and relaxing to do.
Zentangle Inc.	The company founded by Zentangle inventors Maria Thomas and Rick Roberts, owners of rights for the Zentangle teaching method and training for CZT.
Zentangle-inspired art	All works including a Zentangle pattern that are drawn on anything but a tile; that means any form of art and any sizes as well as things such as folded boxes, sneakers, or templates for children, or mixing techniques such as art journaling.
ZIA	Abbreviation for Zentangle-inspired art.

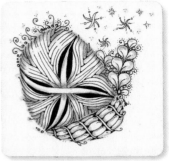

Squill enhancement using Shading, Rounding, and Sparkle

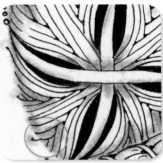

Shading

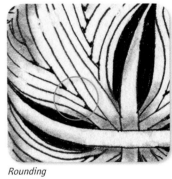

Rounding

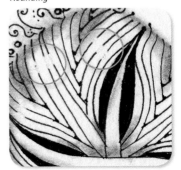

Sparkle

Opportunities for Continuing Tanglers

ZIA – Zentangle-Inspired Art

There are many possibilities and applications for Zentangle. As soon as we leave the tile format behind, we speak of Zentangle-inspired art.

For example, Zentangle can be created for packaging, such as for small boxes, frames, or even sneakers and textiles. It surely is a challenge to draw tangles on a different material, a 3D object, or a bigger space, but Zentangle-adorned objects just simply look charming.

More Zentangle Materials

A black pen and a white piece of paper are great for the pure style of Zentangle. For the advanced ones who want to venture into new surfaces Zentangle developed a few materials:

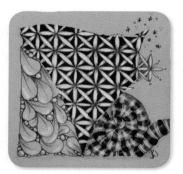

- Tan tiles (Renaissance) with brown and red pens (Sakura Pigma Micron® Pen) and Zentangle Chalk (white chalk, pastels)

- Black tiles with white-glossy pens with 3D effects (Sakura Gelly Roll® Pen), white matte chalk (Zentangle Chalk), white smoky Zenstone (soapstone for smudging), Sakura IDenti® Pen (black with 2 points, works on a lot of surfaces), Fabrico Dual (gray, usually used for textiles, adds light shadows to white chalk)

- Sakura Pigma Micron Pen® in other tip thicknesses: 0.05, 0.8, and 1.0 (graphic brush)

- Watercolor pencils (with brush or water pen for spreading) and the PITT Artist Pen by Faber Castell also work well; from there it is open-ended: acrylic paint, gesso, stamp paint, gouache, or anything else you like.

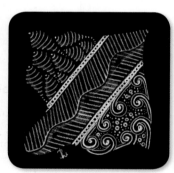

> "Does it have a use?" asked the mind. "No. But I feel good," answered the heart. "But does it have at least a sense?" asked the head. "Oh yes! It benefits us all!" answered all the senses.
> —*Beate Winkler*

When Does Your Heart Sing?

For those who want to know and do more, I have collected information online:
www.beabea.de
mail@beabea.de

More Tangles

Sure, 101 tangles are already a lot, and even with only ten patterns we could go a long way. Even so, there are so many beautiful tangles that it was hard for me to cut it down to 101 tangles for this book.

You can find more tangles, step-outs, and variations at my blog: www.beabea.de

For large pattern databases, go to: www.tanglepatterns.com (by Linda Farmer)
www.elatorium.de (by Ela Rieger)

Tangle-Swap

So you'll always have your favorite tangle ready at hand for a swap, it is useful to tangle the pattern and step-outs onto a larger tag and collect them all on a key ring. I don't mind cutting the tags for you (for scrapbookers: it's done with the machine "Cricut").

Zentangle Videos

If you'd like, take a look over my shoulder. For example, I'll show you step-by-steps for some tangles, how to add shading, and how to create beautiful Zentangle packaging.

Zentangle Classes and Materials

If you'd like to learn Zentangle, you should take a course or a one-on-one class with a CZT. Check www.zentangle.com for a CZT in your area. Most CZTs sell materials as well. If you book a class with me, take this book along and I'll gladly sign it for you. If you have any questions or want to share information, please email me at mail@beabea.de.

Zentangle Books

Zentangle is a wonderful adventure, and a sought-after relaxing technique all over the world. I have also written two Zentangle books for children, as well as two more for adults, *Soulful and Mindful Tangling* and *101 ZIA,* with ideas using a variety of materials, such as a wooden coffee table, a glass door, and a real VW van!

When the patterns start to emerge, calm comes over you. If you like your tanglework, then maybe—step by step—other things are possible, things you didn't think you were capable of.

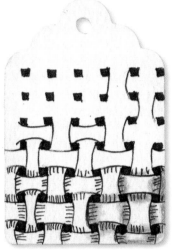

Huggins-W2-Combination

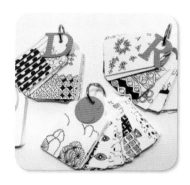

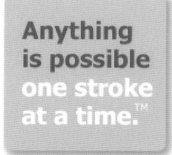

Anything is possible one stroke at a time.™

Rick Roberts and Maria Thomas

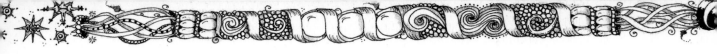

Links

www.beabea.de
Beate Winkler

Here you will find videos, Zentangle artwork, an overview of my designed tangles, class plans, and other craft themes.

www.zentangle.com
Zentangle Inc.

Everything about the company, philosophy, and news, including training offers for CZT.

www.TanglePatterns.com
Linda Farmer, CZT

Includes a huge list of the tangles from around the world.

IamTheDivaCZT.blogspot.de
Laura Harms, CZT

Blog and great weekly challenges. Sometimes a pattern or sometimes something completely different: for example, work out a drink stain as a String (for me it was café au lait).

www.facebook.com/groups/squareonepurelyzentangle/

Square One: Purely Zentangle (public Facebook group)
Weekly tangle main theme; artists can show their work, completely pure style: 3½" (9 cm) square tile, pencil, and black fine-liner.

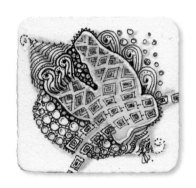

www.mootepoints.com/ebooks.html
Cherryl Moote

You can download a free protective case for the Bijou tile format.

Are all tangles from the company Zentangle?

No, and there is a lot of confusion about it: Zentangle Inc.— Maria Thomas, Rick Roberts, and Maria's daughter Molly Hollibaugh—currently has around 150 tangles published. Many designers have created their own based on Zentangle knowledge. For clarity in this book, I've listed the original tangle name and its designer. You can use and cite these names as reference, mention them in comments, and show tiles in connection with them online.

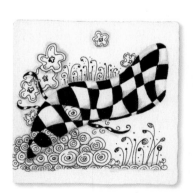

Who Are the Friends?

These are the 56 CZTs and Zentangle friends who helped make this book what it is now.

Even though experts said that I didn't need to, I still wanted to ask all tangle designers for approval to show their designs.

The designers said they felt honored, and some were so enthusiastic that they wanted to participate in the book. You're holding in your hands works from Hong Kong, the United States, Great Britain, Australia, Switzerland, and Germany. What diversity; what a nice variety of styles! The extra effort was all worth it. If something has fallen through the cracks among all the data clutter, I apologize.

I'm touched by the amount of contributions by so many artists and feel very honored. Every time I received a letter, I felt that the sun was shining, and it was like Christmas and my birthday rolled into one. I'm filled with happiness that it all worked out, and that even though the time frame was short, I received submissions from around the world. Promising envelopes arrived in the mail, bringing rapid heartbeats, joy, and astonishment about all the wonderful works of art that made it safely to Hamburg. I'm very happy about it. Thank you so much to all who contributed.

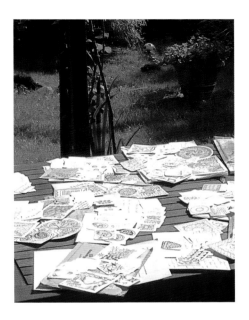

Artist Contributors

Thank you so much, CZT and Zentangle friends around the world, for joining this special book project. You are the ones who made this book a real treasure. I'm so honored and grateful for your collaboration and your fine art work. Hugs, Beate

Arja de Lange-Huisman, CZT, NL
elefantangle.blogspot.com
Designer: 106
Step-outs: 43, 66, 106
Combos: 43, 66, 106

Beth Snoderly, USA/WV
beth.snoderly@yahoo.com
Designer: 51, 92

Carla Du Preez, ZAF
cadp@mweb.co.za
Designer: 33

Carolyn Bruner Russell, CZT, USA/FL
CarolynRussellArt.blogspot.com
Step-out: 83

Catrin-Anja Eichinger, GER
post@festimbild.de
Combo: 6

Conny Holsappel, NL
Designer: 111

Daniele O'Brien, CZT, USA/MI
dobriendesign@comcast.net
Designer: 118

Deborah Pacé, CZT, USA/CA
dpavcreations.blogspot.com
Designer: 95
Step-out: 44
Variations: 32, 85
Combos: 64, 95

Diana Schreur, CZT, NL
www.dischdisch.blogspot.nl
Designer: 60
Step-out: 60
Variations: 60, 104
Combos: 44, 60, 70, 104, 136

Ellen Gozeling, CZT, NL
www.kunstkamer.info
Step-outs: 56, 63, 84, 112
Variations: 56, 63, 84,112
Combos: 56, 63, 84, 112

Frances Banks, CZT, USA/PA
Designer: 30

Genevieve Crabe, CZT, CAN
www.amarylliscreations.com
Designer: 62

Hannah Geddes, CZT, UK
Facebook: Han Made Designs CZT
Designer: 68, 93
Step-outs: 24, 28, 51, 68, 85, 93, 107, 110
Combos: 24, 28, 51, 68, 85, 93, 107, 110

Hanny Waldburger, CZT, CH
www.zenjoy.ch
Designer: 39, 99
Step-outs: 38, 39, 67, 82, 99
Variations: 38, 39, 82, 99
Combos: 39, 67, 82, 96, 99, 101, 102, 137

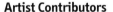

Who Are the Friends?

Helen Wiliams, AUS
alittletime.blogspot.com
Designer: 79

Henrike Bratz, GER
strohsterne-bratz.de
Designer: 116
Variations: 43, 116, 137

Jana Rogers, CZT, USA/ID
jana.pharmhouse@gmail.com
Designer: 67

Jane MacKugler, CZT, USA/VT
dicksallyjane.blogspot.com
Designer: 49, 71, 97
Step-outs: 49, 71, 97
Variation: 49
Combos: 49, 71, 97

Jane Marbaix, CZT, UK
janemarbaix@me.com
Step-outs: 36, 37
Combos: 36, 37

Joyce Block, CZT, USA/WI
mindfulnessinpenandink.blogspot.com
Designer: 105

Judith R. Shamp, CZT, USA/TX
idoso@swbell.net
Designer: 50

Kate Ahrens, CZT, USA/MN
Katetangles.blogspot.com
Designer: 27, 102
Step-outs: 27, 102
Variation: 102
Combos: 27, 102, 136, 137

Katie Crommett, CZT, USA/MA
www.katieczt.com
Designer: 26
Step-outs: 26, 30, 34
Variations: 34, 90
Combos: 26, 30, 90

Katy Abbott, CZT, USA/OH
Katy.abbott@icloud.com
Designer: 78

Dr. Lesley Roberts, CZT, UK
www.theartsoflife.co.uk
Step-out: 120
Variation: 120
Combo: 120

Lisa Lehman, CZT, USA/NY
www.tanglejourney.com
Step-outs: 53, 54, 111, 116
Variation: 116
Combos: 53, 54, 111, 116

Maiko Y. W. Wong, CZT, CN
Maiko.Wong@gmail.com
Designer: 57, 91
Step-outs: 57, 91
Combo: 57

Margaret Bremner, CZT, CAN
enthusiasticartist.blogspot.com
Designer: 65, 83
Variation: 73

Margitta Lippmann-Süllau
info@wosue.de

Maria Thomas, Zentangle® HQ, USA/MA
www.zentangle.com
Designer: 16, 20, 21, 25, 38, 44, 52, 53, 66, 85, 87, 88, 113, 114, 120

Maria Vennekens, CZT, NL
www.zentangle.eu
Designer: 98
Step-outs: 65, 98
Variation: 65
Combos: 65, 90, 98

Mariët Lustenhouwer, NL
www.studio-ML.blogspot.nl
Designer: 70, 104
Step-outs: 70, 104
Variations: 70

Marizaan van Beek, CZT, ZAF
marizaanvb@gmail.com
Designer: 42, 61
Step-out: 61
Variation: 61
Combos: 42, 61

Marty Vredenburg, CZT, USA/MI
martyv41@yahoo.com
Step-outs: 46, 113
Variation: 46
Combos: 16, 46, 113, 136, 137

Mary Kissel, CZT, USA/IL
Tanglegami.blogspot.com
Designer: 46, 77

Mary Elizabeth Martin, CZT, USA/CA
marypinetreestudios@gmail.com
Designer: 39

MaryAnn Scheblein-Dawson, CZT, USA/NY
tangled@paperplay-origami.com
Designer: 58
Step-out: 58
Variation: 58
Combo: 58, 136

Mary-Jane Holcroft, CZT, UK
mjholcroft@hotmail.co.uk
Step-outs: 64, 79
Combos: 64, 79

Michele Beauchamp, CZT, AUS
www.shellybeauch.blogspot.com
Designer: 47, 48, 81
Step-outs: 47, 48, 81
Variation: 47
Combos: 47, 48, 81

Mimi Lempart, CZT, USA/MA
mimi.lempart@gmail.com
Designer: 54, 82

Molly Hollibaugh, Zentangle Inc., USA/MA
www.zentangle.com
Designer: 17, 29, 73, 117

Norma Burnell, CZT, USA/RI
www.fairy-tangles.com
Designer: 56, 64

Rick Roberts & Maria Thomas, Zentangle® HQ, USA/MA
www.zentangle.com
Designer: 18, 19, 22, 28, 31, 32, 34, 35, 74, 84, 90, 96, 101, 107, 110, 120

Sandra Strait, USA/OR
lifeimitatesdoodles@gmail.com
Designer: 43

Sandy Hunter, CZT, USA/TX
tanglebucket@gmail.com
Designer: 37, 115
Variations: 37, 115
Combos: 25, 37, 115

Sharon Caforio, CZT, USA/IL
Designer: 24

Sheena Cable, CZT, UK
ccablefam@aol.com
Step-outs: 87, 88
Combos: 38, 87, 88

Sophia Tsai, CZT, CN/Taiwan
sophiacathytsai@gmail.com
Variation: 137

Stella Peters-Hessels, CZT, NL
www.startangle.blogspot.nl
Designer: 103
Step-outs: 18, 31, 103
Variations: 18, 103
Combos: 18, 21, 31, 103

Stephen Chan, CZT, CN
stephenxstephen@gmail.com
Designer: 75
Step-out: 75
Combos: 75, 127

Sue Clark, CZT, USA/CO
www.tangledinkart.blogspot.com
Designer: 55, 100
Step-outs: 55, 100
Variation: 55
Combos: 55, 100

Sue Jacobs, CZT, USA/IL
suejacobs.blogspot.com
Designer: 59, 63, 86, 112

Susanne Wade, CZT, CAN
mrsdressups@gmail.com
Variations: 86, 118

Tina Hunziker, CZT, CH
hunziker.tina@yahoo.com
Combos: 28, 87

Tricia Faraone, CZT, USA/RI
Designer: 94

Wayne Harlow, CZT, USA/CA
wdharlow@sbcglobal.net
Designer: 80, 119

and me:
Beate Winkler, CZT, GER
Designer: 23, 45, 69, 72, 76, 89
And all other step-outs, variations, and combinations.

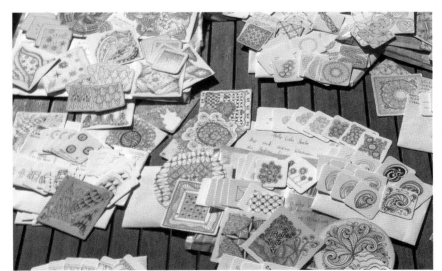

Gallery

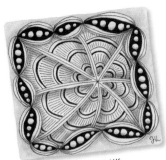

Hannah Geddes, CZT, UK

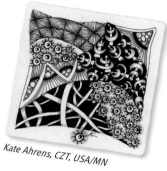

Kate Ahrens, CZT, USA/MN

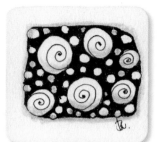

Beate Winkler, CZT, GER

Beate Winkler, CZT, GER

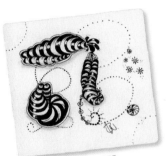

Beate Winkler, CZT, GER

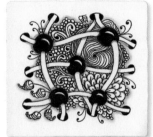

MaryAnn Scheblein-Dawson, CZT,
USA/NY

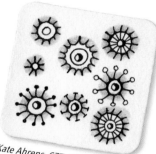

Kate Ahrens, CZT, USA/MN

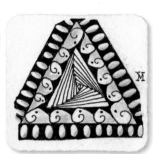

Marty Vredenburg, CZT, USA/MI

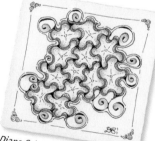

Diana Schreur, CZT, NL

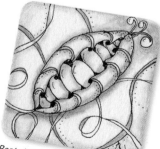

Beate Winkler, CZT, GER

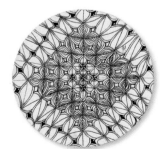

Hanny Waldburger, CZT, CH

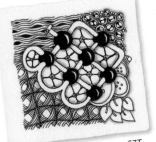

MaryAnn Scheblein-Dawson, CZT,
USA/NY

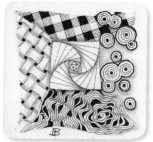

Henrike Bratz, GER

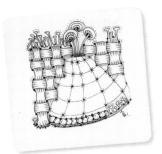

Beate Winkler, CZT, GER

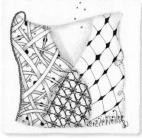

Beate Winkler, CZT, GER

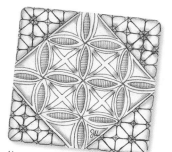

Hannah Geddes, CZT, UK

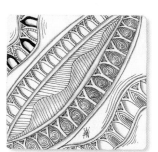

Hanny Waldburger, CZT, CH

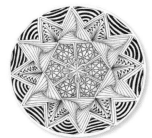

Hannah Geddes, CZT, UK

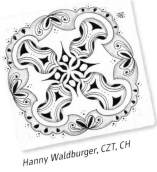

Hanny Waldburger, CZT, CH

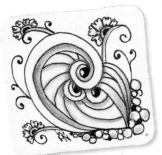

Hanny Waldburger, CZT, CH

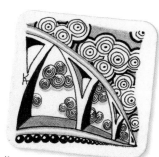

Kate Ahrens, CZT, USA/MN

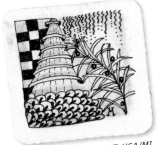

Marty Vredenburg, CZT, USA/MI

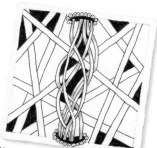

Hannah Geddes, CZT, UK

Sophia Tsai, CZT, CN/Taiwan

Acknowledgments

A special thanks to a few other special people who helped make this book a treasure.

Thanks to **Maria & Rick**, who, with a lot of engagement and detailed steps, share their life's work with the world. They are sincere and so giving. They greet every CZT with a "Welcome aboard!" and keep in contact afterward.

Thank you so much for your wonderful life's work. This is my way to pay you back!

If you're holding this book in your hands you might be able to imagine the many hours of loving, detailed work that went into this. In addition to the artists across the globe who have actively contributed, and are named on the previous pages, and the publisher who whipped it into shape, there were other good spirits who helped out in the background:

All my lovely friends who understood and supported me while disappearing for a few weeks. **Hannah Geddes, UK** (my roommate and for this book a great coworker), and **Hanny Waldburger, CH** (thanks for the collaboration and the German proofreading). **Holly Atwater, USA/CA**, and **Sue Clark, USA/CO** (thank you both for jumping into this translation, proofreading in just two days). My lovely friend **Andrea W.**, who hung an "author-relax-wonder-bag" on my door, and my lovely friend **Margitta**, who was also a German proofreader and from the beginning was on-call and got into every Excel chart. For hours, she rigorously made sure that we were focused on the current task while her husband entertained my dog and made sure we ate. Furthermore, the great star photographer **Catrin-Anja Eichinger**, who for hours with great patience, distraction tactics, and gymnastics tried to shoot a portrait-worthy photo of me. Thank you very much, dearests!

My biggest thanks goes to **Hajo**. Not only did he give me room and space for the project, but he also showed understanding and gave me great help (be it technical, vision, text, proofreading, or photography) and lent support when it started being too much during some intense weeks. For all this I'm grateful to my beloved husband, to the moon and back.

And a special thanks goes to **Barbara Sher**. Her books and seminars "I could do anything if I only knew what I want" have inspired me a lot. When I was whining, "I can't constantly find new, awesome themes and get into it!" she smiled and said, "Sure, honey, you can. You're a scanner," and she explained to me what it meant. Thanks! Thanks! You have changed my life and you will always be in my heart, dearest Barbara.

Maria, Beate, Rick

CZT Europe Meeting 2014

About the Author

Beate (Wiebe) Winkler

When I look back at my childhood, I realize that I spent a lot of time doing arts and crafts, gluing and cutting. After high school, I moved to the Netherlands for two years, grew up, and got into different jobs. I had little time for being creative.

In 1997 I became self-employed in sales and marketing. After years in the field, even though I was successful (by now I had seven employees), I noticed I was missing something. So I closed my company's doors and took a year sabbatical. At the end of that year I knew: I like speaking at seminars, but I also would like to do something with my hands again. Three months later my plan became reality. I held my first crafting seminar. For the last ten years my main job has been an arts and craftswoman. I design products and teach creativity classes for adults and children. During the years I have been able to meet and welcome more than 10,000 participants.

After I read the book *Craft to Heal*, I learned the reason why I love to hold creativity seminars. I call it "Let the soul do arts and crafts." As an arts and craftswoman, I always love new trends. That's why I visit trade shows such as the Craft & Hobby Association Mega Show, in the United States, and Paperworld, in Germany. My favorite medium is, and always will be, paper (scrapbooking, greeting cards, packaging, art journaling, and so on), but I also like natural materials, such as pearls, felt, and cotton. My goal in life? I want to help increase creativity by one percent in Germany, where only 3–4 percent of people are crafting—not that much, right? I'm a globetrotter. I've lived in a lot of foreign countries (Netherlands, Thailand, and Mallorca, to name a few) and during a six-month sabbatical I traveled with my sweetheart through forty U.S. states in a camper.

How did Zentangle come into my life? While conducting online research for upbeat new themes, I noticed beautiful graphic patterns that fascinated me. I was hooked right away and within seconds I had a fine-liner pen in my hand to give it a try. Everybody who came into my studio, no matter their questions, learned about Zentangle, and usually left as a fan. I hope you feel the same!

How did I become a Certified Zentangle Teacher (CZT)?

I always love to try new things, and I have a curious eye for fresh new trends, but surprisingly Zentangle has been at the top of my top-ten list for over a year. Even my husband noticed it, and he urged me to fly to the States to meet Rick and Maria and become a CZT. I was on the waiting list for a long time until I got a notification letting me know I could participate. I canceled all of my standing appointments, booked a flight and hotel, and was on my way to Providence, Rhode Island. I had the time of my life!

For more information, go to www.zentangle.com.

I am proud to be a CZT.

All Tangles from A to Z

Ahh (p. 18)

Angle Fish (p. 42)

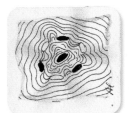

Appearance (p. 43)

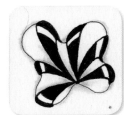

Aquafleur (p. 44)

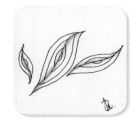

Aura-Leah (p. 33)

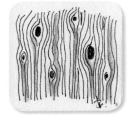

B-horn (p. 45)

Birds on a Wire (p. 46)

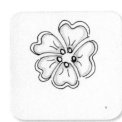

Blooming Butter (p. 47)

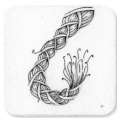

Brayd (p. 48)

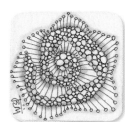

Bubble Bobble Bloop (p. 49)

Bumpety Bump (p. 50)

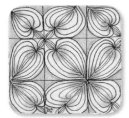

Bumpkenz (p. 51)

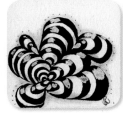

Bunzo (p. 52)

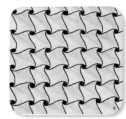

Cadent (p. 53)

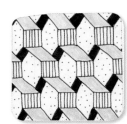

Casella (p. 111)

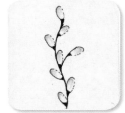

Cat-kin (p. 54)

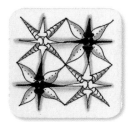

Ceebee (p. 55)

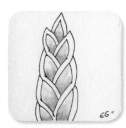

Chainlea (p. 56)

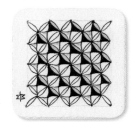

Checkers (p. 57)

Chemystery (p. 58)

Coil (p. 59)

Connessess (p. 60)

Cool 'Sista (p. 61)

Crescent Moon (p. 20)

Cruffle (p. 37)

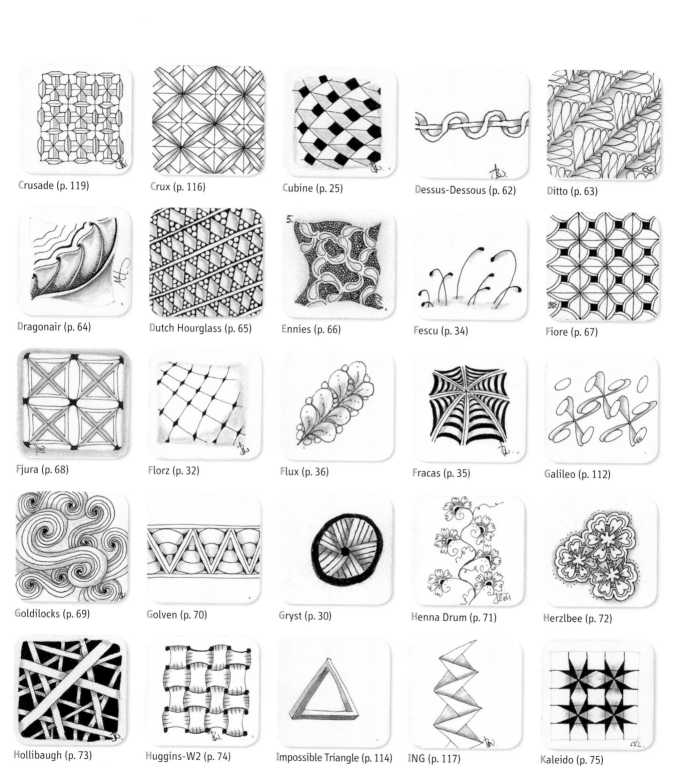

Crusade (p. 119)

Crux (p. 116)

Cubine (p. 25)

Dessus-Dessous (p. 62)

Ditto (p. 63)

Dragonair (p. 64)

Dutch Hourglass (p. 65)

Ennies (p. 66)

Fescu (p. 34)

Fiore (p. 67)

Fjura (p. 68)

Florz (p. 32)

Flux (p. 36)

Fracas (p. 35)

Galileo (p. 112)

Goldilocks (p. 69)

Golven (p. 70)

Gryst (p. 30)

Henna Drum (p. 71)

Herzlbee (p. 72)

Hollibaugh (p. 73)

Huggins-W2 (p. 74)

Impossible Triangle (p. 114)

ING (p. 117)

Kaleido (p. 75)

All Tangles from A to Z

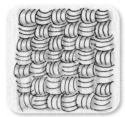
Keeko (p. 19)

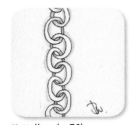
Kettelbee (p. 76)

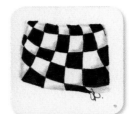
Knightsbridge (p. 22)

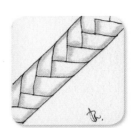
Ko'oke'o (p. 77)

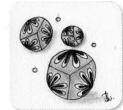
Kuke (p. 78)

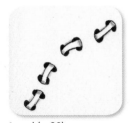
Laced (p. 39)

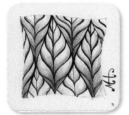
Leaflet (p. 79)

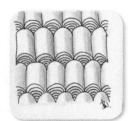
Logjam (p. 80)

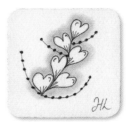
Luv-A (p. 24)

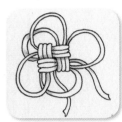
Mak-rah-mee (p. 81)

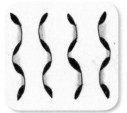
MI2 (me too) Version I (p. 82)

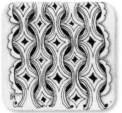
MI2 (me too) Version II (p. 82)

Mooka (p. 120/121)

Moving Day (p. 83)

M'Spire (p. 26)

Msst (p. 31)

Munchin (p. 29)

Nipa (p. 84)

'Nzeppel (p. 85)

'Nzeppel Random (p. 85)

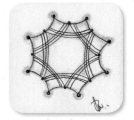
Octonet (p. 86)

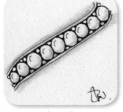
Onamato (p. 21)

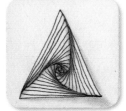
Paradox (p. 87)

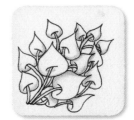
Poke Leaf (p. 88)

Potterbee (p. 89)

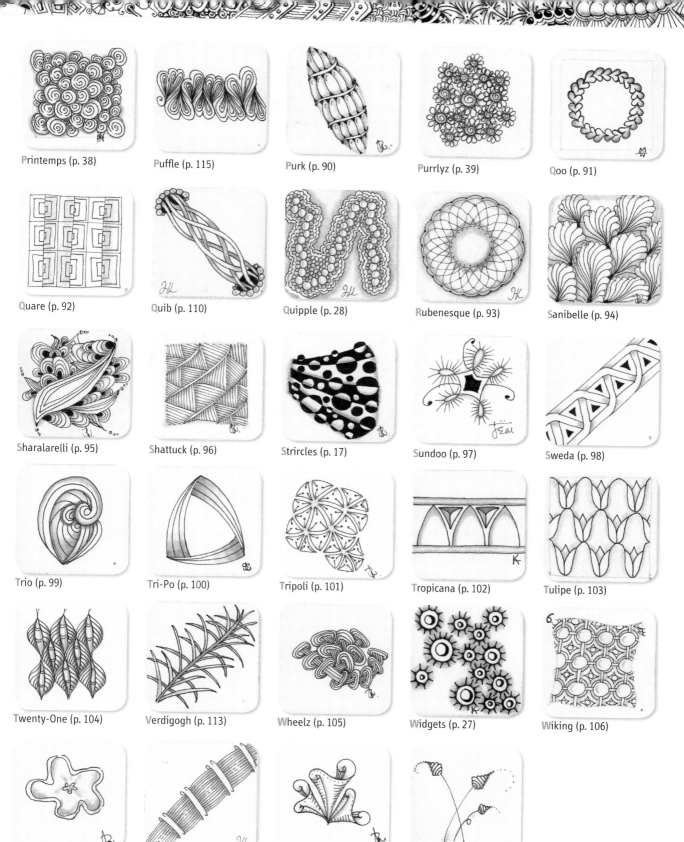

Printemps (p. 38)

Puffle (p. 115)

Purk (p. 90)

Purrlyz (p. 39)

Qoo (p. 91)

Quare (p. 92)

Quib (p. 110)

Quipple (p. 28)

Rubenesque (p. 93)

Sanibelle (p. 94)

Sharalarelli (p. 95)

Shattuck (p. 96)

Strircles (p. 17)

Sundoo (p. 97)

Sweda (p. 98)

Trio (p. 99)

Tri-Po (p. 100)

Tripoli (p. 101)

Tropicana (p. 102)

Tulipe (p. 103)

Twenty-One (p. 104)

Verdigogh (p. 113)

Wheelz (p. 105)

Widgets (p. 27)

Wiking (p. 106)

Winkbee (p. 23)

Zander (p. 107)

Zenplosion Folds (p. 118)

Zinger (p. 16)